Items should be returned on or before the last date
shown below. Items not already requested by other
borrowers may be renewed in person, in writing or by
telephone. To renew, please quote the number on the
barcode label. To renew online a PIN is required.
This can be requested at your local library.
Renew online @ **www.dublincitypubliclibraries.ie**
Fines charged for overdue items will include postage
incurred in recovery. Damage to or loss of items will
be charged to the borrower.

Leabharlanna Poiblí Chathair Bhaile Átha Cliath
Dublin City Public Libraries

Ráth Eanaigh
Raheny Branch
Tel: 8315521

Dublin City
Baile Átha Cliath

Date Due	Date Due	Date Due
15 SEP 2011	13 JUN 2012	
17/10/11		17 MAY 2016
1 8 MAY 2015	0 8 NOV 2012	17 MAY 2016
	0 9 MAY 2013	1 4 DEC 2016
	2 8 JAN 2014	
	- 6 MAR 2014	2 9 AUG 2017
		2 3 MAY 2018
23 APR 2015	3 1 MAY 2019	3 1 OCT 2018
	0 5 JUN 2010	

Oil-painting
Workshop

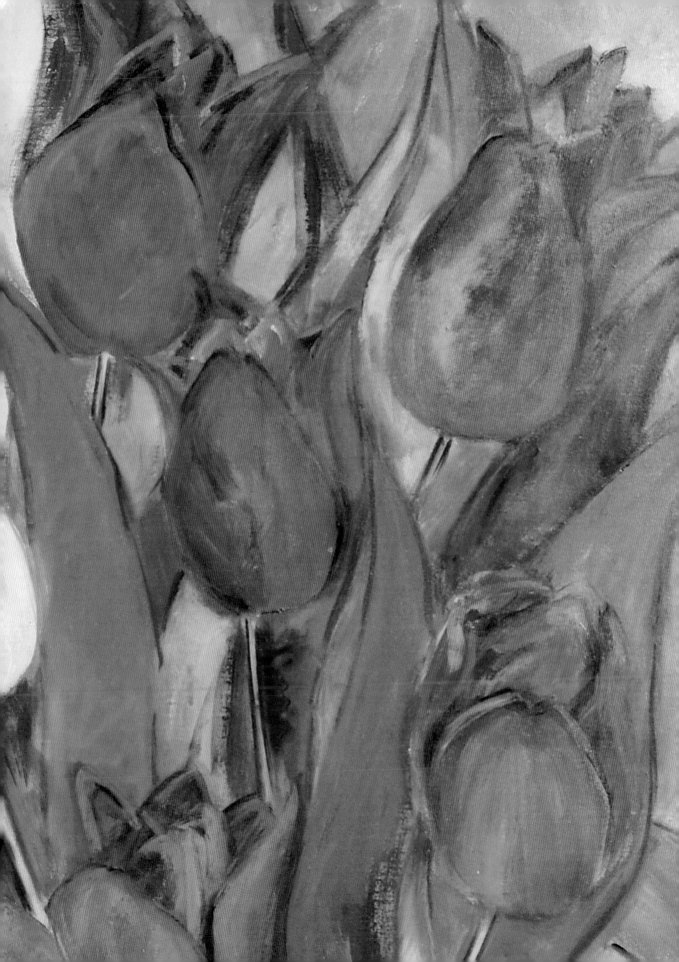

Oil-painting Workshop

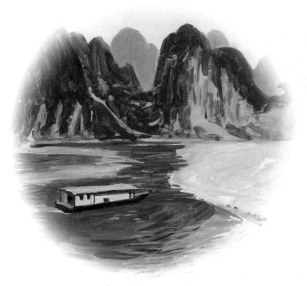

Aggy Boshoff

A Dorling Kindersley Book

DK

LONDON, NEW YORK, MELBOURNE,
MUNICH, DELHI

Project Editor Kathryn Wilkinson
Project Art Editor Anna Plucinska
DTP Designer Adam Walker

Managing Editor Julie Oughton
Managing Art Editor Christine Keilty
Production Controller Rita Sinha
Photography Andy Crawford

Produced for Dorling Kindersley by
Design Gallery
Art Editor Vanessa Marr
Project Editor Geraldine Christy
Managing Editor David Garvin

First published in Great Britain in 2006 by
Dorling Kindersley Limited
80 Strand, London WC2R 0RL

A Penguin Company

2 4 6 8 10 9 7 5 3

A CIP catalogue record for this book
is available from the British Library.

ISBN-13: 978 1 4053 1579 1
ISBN-10: 1 4053 1579 2

Printed and bound in China by
Hung Hing Offset Printing Company Ltd

Discover more at
www.dk.com

Contents

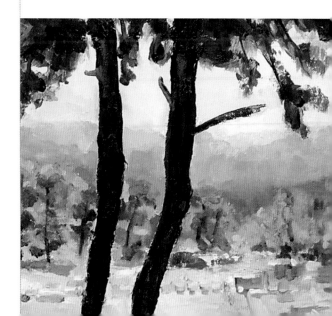

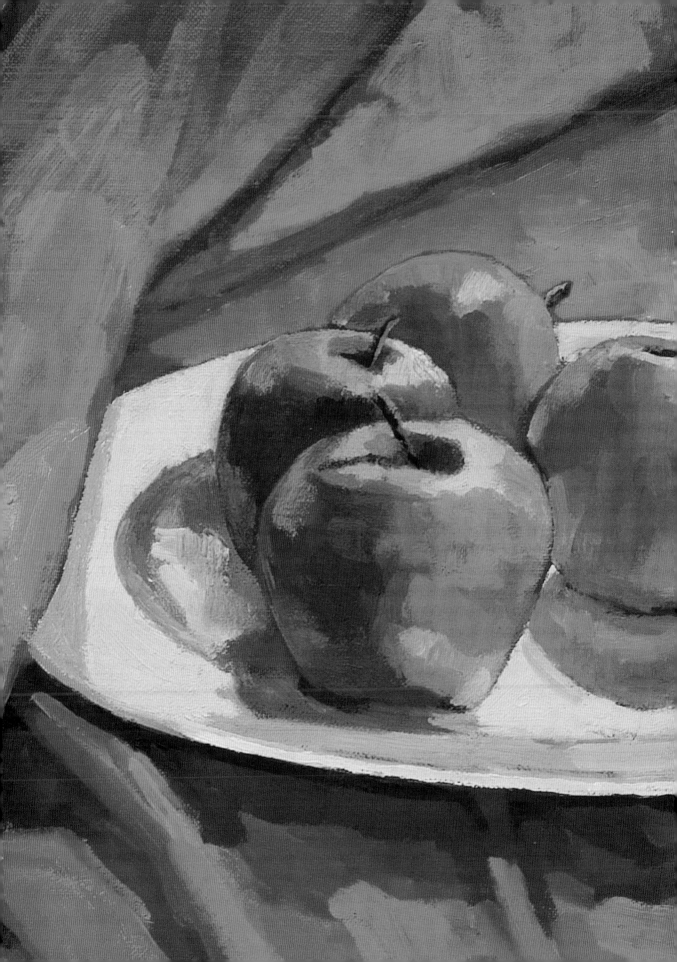

Introduction

Oil paint is a very expressive medium to use, with sensuous, tactile textures and glowing colours. However, perhaps because of its association with the Old Masters and other towering figures in the world of art, it is often regarded as having a certain mystique that puts it beyond the successful reach of the novice. In fact, it is a forgiving medium that is easy to work with, for you can simply clean or scrape off anything that you are not pleased with and start again.

A versatile medium

Oil painting originated in northern Europe in the 15th century, and its stability, textural variety, and slow-drying nature that enabled artists to work on a painting over a period of days, meant that by the

16th century it had become the favourite medium of artists all over Europe. The paint could be thinned with turpentine and oil to give it great translucency, while at the same time achieving the deep, rich colours that both pleased wealthy patrons wanting to be portrayed in all their rich finery and imbued religious and secular subjects with depth and sensuousness.

Oil paint is also delicious for the artist to handle. It has great plasticity, which means it can be moulded into many different textures, and even when it is applied thinly it possesses a pleasing body and malleability. This is because of the oil with which the pigments are premixed in the tubes and also the oil in the painting medium, with which the paints are mixed on the palette before the brush is put to canvas. It allows patient, subtle work with a fine brush, or, depending on the artist's temperament and intentions, vigorous applications with a knife to plaster it thickly on the support. Of all media, it allows for the greatest versatility of technique, but is also capable of throwing up chance effects, which add to the magic of using it and encourage the development of the artist.

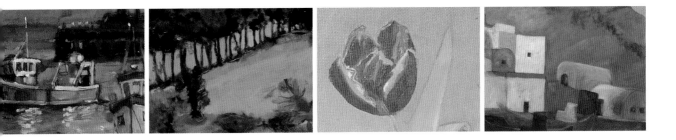

Learning to paint in oils

This book is a hands-on approach to painting in oils and aims to set the budding artist on the path to using this most satisfying medium with enthusiasm and confidence. It begins by detailing the pigments, brushes, and other equipment you will need, including new products that take away some of the perceived problems for the amateur artist using oils in the home, such as odour and slow-drying paintings propped up about the place. You will discover the techniques of applying paint, from translucent glazes to thick impasto, and learn about colour mixing, both in practical terms and in the use of contrasting and harmonizing colours to bring vibrancy and balance to your paintings. Each chapter takes you a step further to a concise understanding of what oil painting is about, and galleries of paintings by various artists illustrate the points made in the text. There are also 12 projects, each of which take you step by step through the process of creating a painting, making use of all the techniques explained in the book and helping you to realize that you are able to create finished paintings on a wide range of subjects.

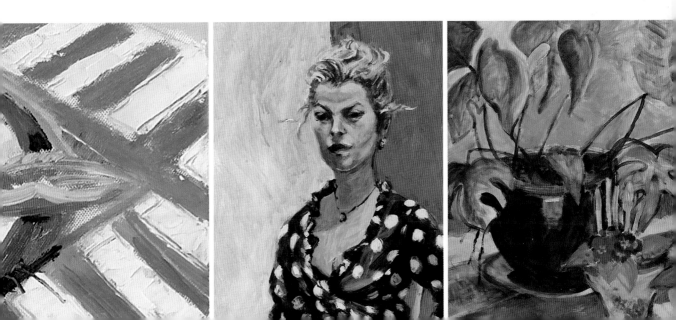

Materials and Techniques

Paint and other materials

There is a wide choice of oil paints available in tubes or pots, varying in strength of pigment and quality. The best quality paints are professional or "Artists' colours". These contain stronger pigments than "Students' colours", so they have more brilliance, more covering power, and are less likely to change with time. Limit the number of colours you purchase in favour of buying Artists' paints.

RECOMMENDED COLOURS

The 15 colours below make up a useful standard palette. With this number of colours you will have a good ready choice when painting, because with these you will be able to make virtually any colour by mixing two or more together. You may want to add a few more colours that you particularly like. It is often economical to buy the colours that you use most, such as titanium white, in a larger tube.

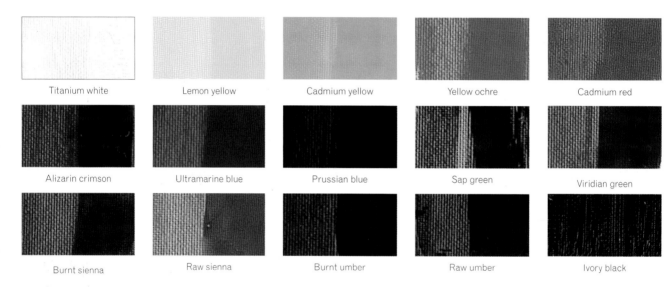

Titanium white	Lemon yellow	Cadmium yellow	Yellow ochre	Cadmium red
Alizarin crimson	Ultramarine blue	Prussian blue	Sap green	Viridian green
Burnt sienna	Raw sienna	Burnt umber	Raw umber	Ivory black

OIL PAINT VARIATIONS

The drying time of Artists' oil colours can vary from a few days to a few weeks, depending on how thick the paint is applied. Alkyd paints are faster drying oil paints, and their drying time is a fraction of that of traditional oil paints, so they are handy for painting outdoors. Water-mixable oil colours contain an oil binder that has been modified to mix with water, so these paints take even less time to dry.

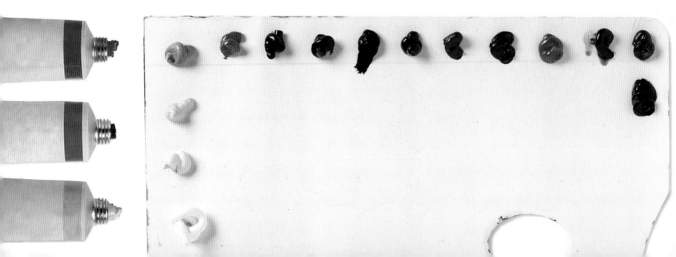

OTHER MATERIALS

You need about six brushes to start with, and two or three painting knives, a fan brush for blending, and a 25mm (1in) brush for priming and varnishing (not shown). A palette is indispensable, on to which can be clipped a dipper for painting mediums. You also need a rag to wipe off paint, a jar of white spirit to clean hands and brushes, and protective clothing.

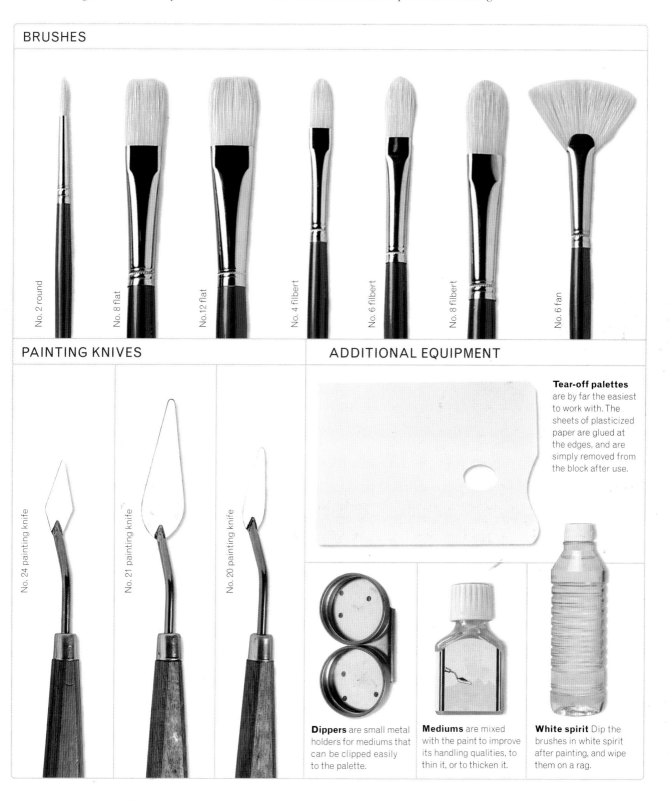

BRUSHES

No. 2 round

No. 8 flat

No.12 flat

No. 4 filbert

No. 6 filbert

No. 8 filbert

No. 6 fan

PAINTING KNIVES

No. 24 painting knife

No. 21 painting knife

No. 20 painting knife

ADDITIONAL EQUIPMENT

Tear-off palettes are by far the easiest to work with. The sheets of plasticized paper are glued at the edges, and are simply removed from the block after use.

Dippers are small metal holders for mediums that can be clipped easily to the palette.

Mediums are mixed with the paint to improve its handling qualities, to thin it, or to thicken it.

White spirit Dip the brushes in white spirit after painting, and wipe them on a rag.

Supports

A support is the surface you paint on. All supports need to be primed before use, so that the surface is sealed and the support does not absorb the paint. Paper blocks of oil painting paper, and some canvas boards and canvases, are sold ready primed. Primed supports are white. Canvas is the classic oil painting support and is available in cotton or linen, but many artists prefer to paint on board.

TYPES OF SUPPORT

Oil painting paper, canvas, canvas board, MDF board, and hardboard are all suitable supports for oil painting. Their surface textures vary from fine, through medium, to rough. Experiment with supports to see which surface suits you best. Do not buy your support too small; a size of about 40 x 50cm (15 x 20in) will allow you space to work.

Oil painting paper is available in specially prepared blocks. Primed heavyweight watercolour paper is also suitable for oil painting.

Canvas may be cotton or linen. Cotton canvas is less expensive than linen, but linen canvas keeps its tautness better.

Canvas board is available ready primed in different sizes in art shops. It is board with a linen texture paper glued on it.

Multi Density Fibre (MDF) board comes in different thicknesses and has to be cut to size.

Hardboard provides both a smooth and a rough, textured side and, like MDF, is reasonably priced.

DIFFERENT SURFACES

The traditional support for oil painting is canvas, which lasts for centuries. Canvas has a stretch to it that responds to the pressure of the brush. Good quality boards primed with acrylic gesso are less expensive and may last as long. The paintings here show the results obtained on different supports.

Canvas The paint is applied thickly on this medium texture cotton canvas. Canvas is available in many different textures from fine to rough.

Canvas board The paint is applied medium thick on this medium grain canvas board. This leaves the possibility of adding finer detail.

Oil painting paper This is a medium fine paper with the paint used medium to thick. The paper can be glued to a board or canvas later.

MDF board The surface is smooth and without grain. The paint is worked medium thick and shows the individual hairlines of the brush.

Hardboard Both sides are suitable for impasto. Here the paint is applied medium thick on the rough side. The smooth side is like MDF.

PRIMING THE SUPPORT

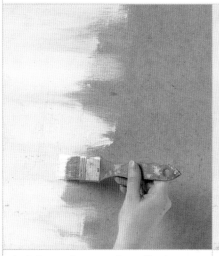
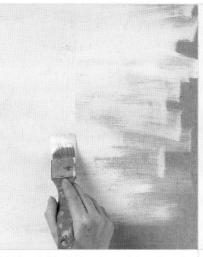

Apply the acrylic gesso primer with a large primer brush or a large household brush, moving the brush with bold strokes.

Paint from left to right, and up and down, to seal the support properly, and to give a good key to the surface so that the paint will adhere.

Allow the gesso to dry before starting the painting. Drying will only take 30 minutes to an hour, unless the primer is applied with thick texture.

Brushes and painting knives

Brushes come in different qualities and price ranges, but hog bristle brushes are generally recommended for oil painting. Hog brushes with a natural spring are likely to last longer. Sable or nylon brushes can be used for glazes and fine work. Sable brushes are expensive; nylon brushes are more reasonably priced. You can also paint with a painting knife. The handle of a painting knife is cranked to lift it from the paint surface.

BRUSH SHAPES

There are four shapes of brushes: round, flat, filbert, and fan. Brushes are numbered from 1 to 24, and the lower the number the smaller the brush. For a starter set include a No. 2 round, a No. 8 and No. 12 flat, a No. 4, No. 6, and No. 8 filbert, and a No. 6 fan brush. Choose a round brush that comes to a good point. It is useful to have more brushes in the middle sizes.

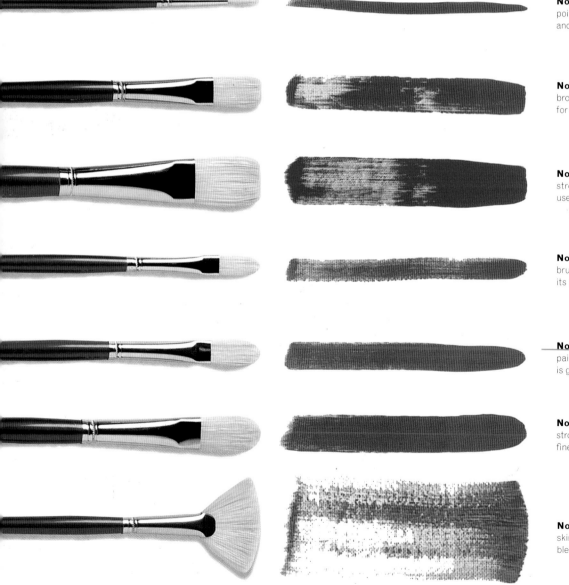

No. 2 round is perfect used pointed for lines and details, and is also used on its side.

No. 8 flat is used flat for a broad stroke, or on its side for a thinner line.

No. 12 flat gives a broader stroke, and the top can be used to make straight edges.

No. 4 filbert is a versatile brush, used flat as here, on its side, or on its point.

No. 6 filbert holds more paint. The rounded point is good for blending.

No. 8 filbert gives a broader stroke, but can still create a fine line used on its side.

No. 6 fan is used lightly to skim the surface, and softly blend and feather.

PAINTING KNIVES AND THEIR MARKS

No. 20 painting knife
is useful for applying
little flecks of paint,
and small impasto work.

No. 21 painting knife
is suitable to paint
sharp edges, petal
shapes, and impasto.

No. 24 painting knife
is good for smaller
work, sharp edges,
and impasto work.

HOW TO HOLD A BRUSH AND PAINTING KNIFE

Hold the brush about halfway along the handle for most of your painting. Paint with a stretched arm, and move your arm around freely over the painting and outside it. For finer detail and smaller shapes move your hand closer to the brush, but hold it lightly. Always use the largest brush for the space. Hold the painting knife like a knife. You can push paint onto the support with the painting knife both sideways, as shown in the marks above, and lengthways.

For flowing brushmarks hold the brush like you would hold a knife. Move the wrist and arm around to make free and easy brushstrokes.

For finer detail hold the brush like you would hold a pen. Make short or dabbing movements to deposit the paint for detail.

Keep your thumb on or to the side of the handle of the knife. Move towards the hand or roll the wrist inwards for a sideways dab.

Brushstrokes

Practise holding the brush at different angles, from upright to flat, and almost parallel to the paint surface. Vary the pressure and move the brush in different directions turning your wrist. Try out a line, a colour field, and dabbing. Experiment with the various types of brushes and painting knives to make abstract marks. Break up a line or colour field with varied brushstrokes for a playful effect.

VISUAL EFFECTS

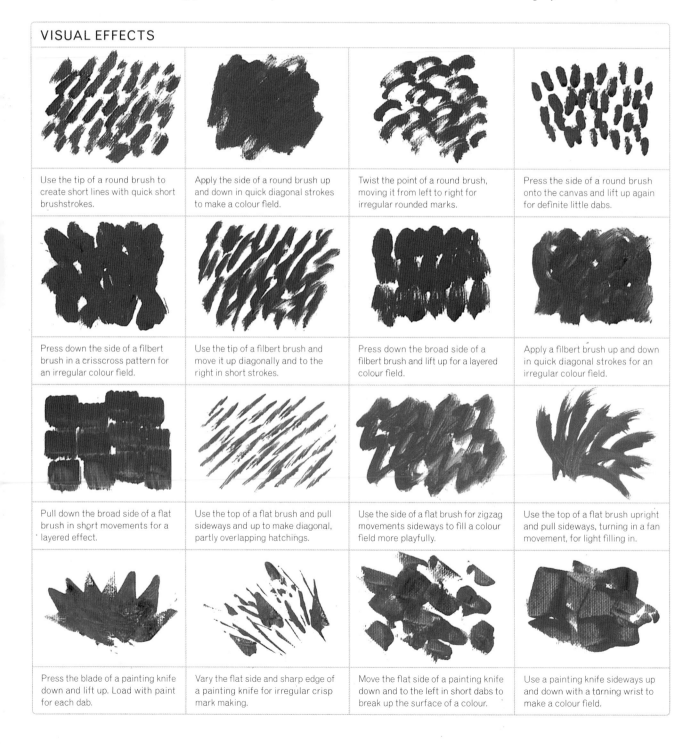

Use the tip of a round brush to create short lines with quick short brushstrokes.

Apply the side of a round brush up and down in quick diagonal strokes to make a colour field.

Twist the point of a round brush, moving it from left to right for irregular rounded marks.

Press the side of a round brush onto the canvas and lift up again for definite little dabs.

Press down the side of a filbert brush in a crisscross pattern for an irregular colour field.

Use the tip of a filbert brush and move it up diagonally and to the right in short strokes.

Press down the broad side of a filbert brush and lift up for a layered colour field.

Apply a filbert brush up and down in quick diagonal strokes for an irregular colour field.

Pull down the broad side of a flat brush in short movements for a layered effect.

Use the top of a flat brush and pull sideways and up to make diagonal, partly overlapping hatchings.

Use the side of a flat brush for zigzag movements sideways to fill a colour field more playfully.

Use the top of a flat brush upright and pull sideways, turning in a fan movement, for light filling in.

Press the blade of a painting knife down and lift up. Load with paint for each dab.

Vary the flat side and sharp edge of a painting knife for irregular crisp mark making.

Move the flat side of a painting knife down and to the left in short dabs to break up the surface of a colour.

Use a painting knife sideways up and down with a turning wrist to make a colour field.

APPLYING STROKES

Just a few abstract strokes and dashes can create simple sketches. Practise images like sheep in a field, a palm tree, and a pot of geraniums.

Try making most marks with a No. 4 filbert brush. Make only some very dark marks in the pot with a No. 2 round brush.

Use a No. 8 flat brush for the darker brown of the tree trunk, and the tip and side of a No. 2 round brush for all the other marks.

Use a No. 6 filbert brush for the wider, short, and overlapping marks of sheep and meadow. Use a No. 2 round brush for details.

Colour wheel

The colour wheel is an easy way of showing how the three primary colours – yellow, red, and blue – can be mixed to form the three secondary colours of orange, violet, and green. Adding more of one primary colour to these secondary colours creates a further six intermediate colours to form a colour wheel of 12 colours. The primary colours form the strongest colour contrast, but any two colours on opposing sides of the wheel make each other look brighter when placed together. These are called complementary colours.

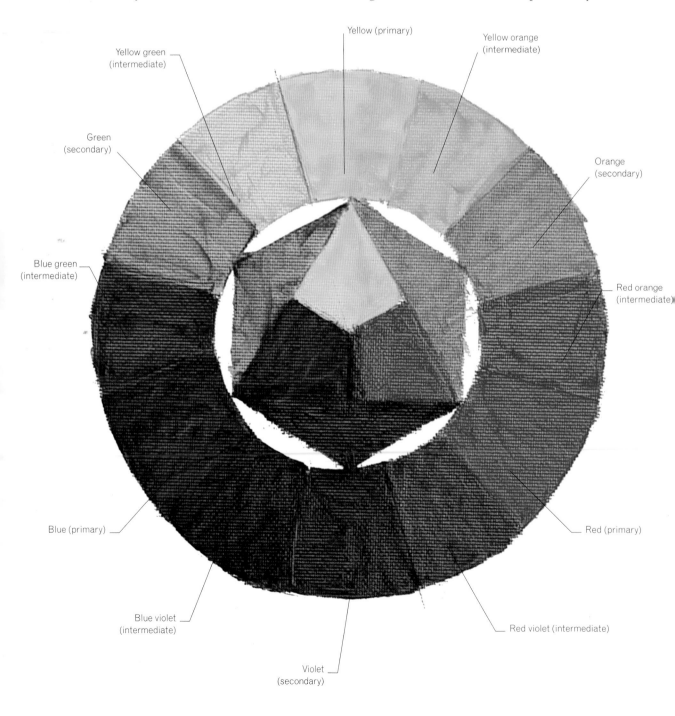

Yellow (primary)

Yellow orange (intermediate)

Yellow green (intermediate)

Green (secondary)

Orange (secondary)

Blue green (intermediate)

Red orange (intermediate)

Blue (primary)

Red (primary)

Blue violet (intermediate)

Red violet (intermediate)

Violet (secondary)

COMPLEMENTARY COLOURS

Colours that are opposite each other on the colour wheel also form strong contrasts. These pairs are called complementary colours, and they make each other look brighter when used together.

PRIMARY	PRIMARY	SECONDARY	COMPLEMENTARY

 + **=**

Yellow and red make orange. Blue is the other primary colour, so is the complementary colour of orange.

 + **=**

Yellow and blue make green. Red is the other primary colour, so is the complementary colour of green.

 + **=**

Red and blue make violet. Yellow is the other primary colour, so is the complementary colour of violet.

Colour mixing

Colours are mixed to create new colours by stirring them around with each other and blending them on the palette. Squeeze out the 15 colours of the recommended colour palette on the edge of the palette first. You can also mix colours directly on the support when the paint is mixed wet-in-wet with the lower paint layer. This usually results in the colours partly blending with each other.

MIXING ON A PALETTE

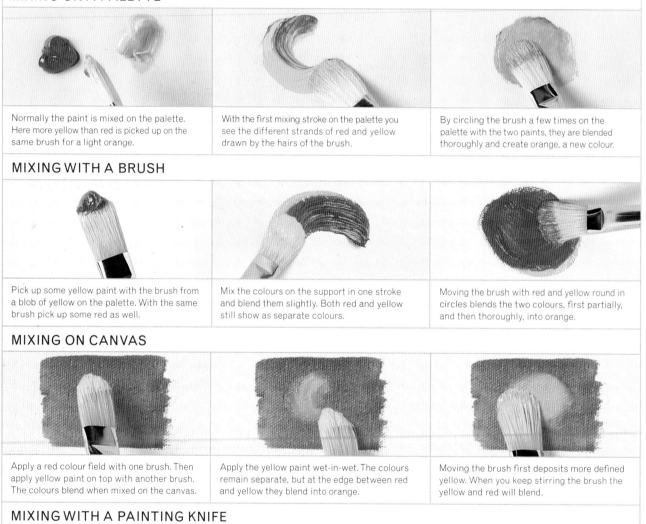

Normally the paint is mixed on the palette. Here more yellow than red is picked up on the same brush for a light orange.

With the first mixing stroke on the palette you see the different strands of red and yellow drawn by the hairs of the brush.

By circling the brush a few times on the palette with the two paints, they are blended thoroughly and create orange, a new colour.

MIXING WITH A BRUSH

Pick up some yellow paint with the brush from a blob of yellow on the palette. With the same brush pick up some red as well.

Mix the colours on the support in one stroke and blend them slightly. Both red and yellow still show as separate colours.

Moving the brush with red and yellow round in circles blends the two colours, first partially, and then thoroughly, into orange.

MIXING ON CANVAS

Apply a red colour field with one brush. Then apply yellow paint on top with another brush. The colours blend when mixed on the canvas.

Apply the yellow paint wet-in-wet. The colours remain separate, but at the edge between red and yellow they blend into orange.

Moving the brush first deposits more defined yellow. When you keep stirring the brush the yellow and red will blend.

MIXING WITH A PAINTING KNIFE

Use a painting knife to pick up yellow and blue from the palette to mix into a green. Keep the blobs as clean as you can.

With one movement of the painting knife both blue and yellow, and the newly mixed colour, green, are visible.

Moving the palette knife back and forth mixes the paints thoroughly, although variations in the paint may still be detected.

MIXING WITH TWO COLOURS

With the recommended standard palette of 15 colours you can make almost any colour you wish. The colour wheel shows how two primary colours can be mixed to form the secondary colours. Here different oranges and violets are made by mixing the various yellows, reds, and blues on the palette. The two resulting violets are then mixed with white to show that they are different violets.

Cadmium yellow and alizarin crimson make a mid orange because their hues are equally strong.

Lemon yellow and alizarin crimson make a darker orange because alizarin crimson is a more dominant colour than lemon yellow.

Alizarin crimson and ultramarine blue make a mid violet because alizarin crimson and ultramarine blue are equally strong colours.

Alizarin crimson and Prussian blue make a darker, and bluer, violet because Prussian blue is the stronger of the two.

Mixing the first violet, made from alizarin crimson and ultramarine blue, with white gives a good strong lilac.

Mixing the second violet, made from alizarin crimson and Prussian blue, with white makes a rather cool grey blue.

SEPARATE BRUSHES

It is good practice to keep some brushes with important colours going, during painting, so that you can come back to them. This saves effort and paint. It speeds up your painting when you can use the same brushes quickly to pick up some more of the various paint mixes on the palette.

Hold brushes with important colours in your non painting hand.

You can also keep saved brushes upright in a pot for used brushes.

Mixing darks and lights

It comes as a surprise that whereas mixes of two colours give clear new colours, when three colours are mixed together the results are neutral colours. Depending on the colours mixed, ranges of neutrals with subtle differences can be created, from dark to light. Two or more different pigments can also tone down colour. Neutral colours are important foils for bright colours and can make them sing.

MIXING NEUTRALS FROM PRIMARY COLOURS

When all three primary colours are mixed together in equal amounts they make a dark or neutral colour. You can create an infinite variety of colourful darks by varying the proportions of each primary colour.

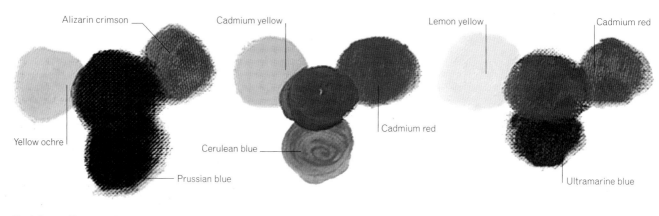

Dark brown Prussian blue is the stronger colour and dominates both alizarin crimson and yellow ochre.

Light brown Cerulean blue, which is a lighter, weaker blue, mixes with cadmium yellow and cadmium red to create a lighter brown.

Reddish brown The combination of cadmium red and ultramarine blue dominates the weaker lemon yellow to form a reddish brown.

MIXING NEUTRALS FROM COMPLEMENTARY COLOURS

You can also mix two complementary colours together to make a colourful neutral. Yellow mixed with violet, red mixed with green, or blue mixed with orange, make neutral colours that set off strong colours well. Adding just a little of the complementary colour can tone down or modify the brightness of a colour.

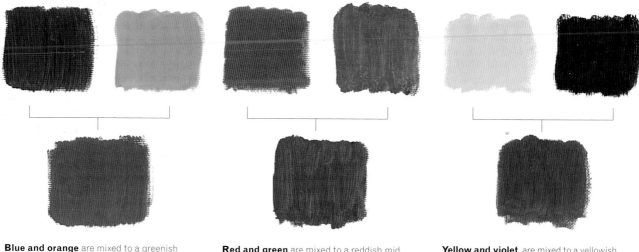

Blue and orange are mixed to a greenish mid brown. The outcome will be darker when a stronger blue is used.

Red and green are mixed to a reddish mid brown. The outcome will be cooler when using a stronger green.

Yellow and violet are mixed to a yellowish mid brown. The outcome will be darker when using yellow ochre.

MIXING WITH BLACK AND WHITE

Colours can be lightened or darkened by mixing them with other colours. They can also be lightened or darkened by mixing them with black and white. In the chart below the first horizontal row shows five variations of grey between white and black. The other rows show variations of some of the colours recommended for the standard palette when white and black are added.

+ white ——————— Colour from the tube ——————— + black

Titanium white

Lemon yellow

Cadmium yellow

Cadmium red

Alizarin crimson

Ultramarine blue

Prussian blue

Raw sienna

Burnt sienna

Raw umber

Burnt umber

Glazes

A glaze is a larger area of diluted and transparent paint used on its own or laid over other glazes. The paint is made thin and translucent by adding turpentine or odourless thinner to the paint or a thin mixture of turpentine and oil, using two parts turpentine to one part oil. You can also add an alkyd-based glazing medium to the paint to make a glaze. A scumble glaze lets the undercolour show more unevenly.

LAYING GLAZES

A painting is usually built up of several layers of paint. Try laying a single glaze and then practise painting a second glaze over the top using a different colour. A useful way of toning down a colour is to apply a second glaze in its complementary colour over it.

SINGLE GLAZE

Use a flat brush. Dilute cadmium red with turpentine or a glazing medium and start to paint a colour field with broad overlapping strokes.	Draw the brush in parallel movements until you have a block of colour. The white undercoat shimmers or shines through.	Check the consistency of the colour and lift some paint off by squeezing your brush dry and painting over the colour field again.

OVERGLAZE (YELLOW OVER RED)

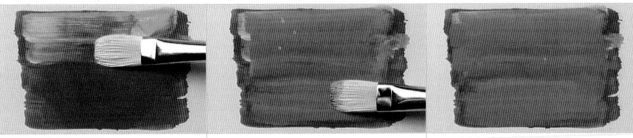

When the paint is still wet start applying an equally thin and transparent layer of yellow. Here the yellow is used somewhat too dry.	Dip the paint in the medium and slowly drag the yellow over the red in fluid movements. A shimmering orange results.	The two wet layers mix slightly, but you can still distinguish the two separate colours. Check and refine the second glaze.

OVERGLAZE (RED OVER YELLOW)

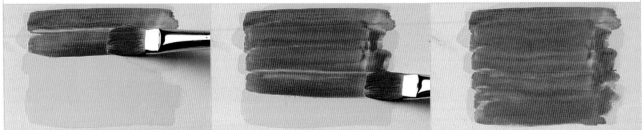

Lay a yellow underglaze with a thin mixture of oil and turpentine. The white of the support shines through in places.	Now draw a clean brush with an equally thinned red over the yellow glaze in fluid movements to create a red veil over the yellow.	The two colours mix slightly on the support, but can still be distinguished. A vivid orange is the result, showing some variations.

OVERGLAZE WITH COMPLEMENTARY COLOUR

Paint a thin glaze of viridian green first. With a clean brush, draw a glaze of cadmium red over the green in slow movements.

Apply the red glaze in overlapping strokes. The two complementary colours form a mid reddish brown, with the green showing through in places.

Check the consistency of the top glaze by going over the area again and softening the overlaps of paint, but do not overwork the new colour.

SCUMBLE GLAZE

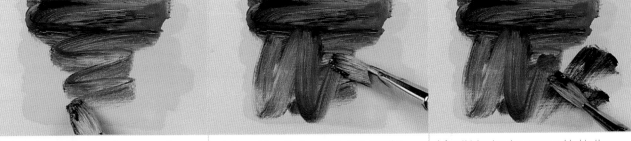

At the top, apply a green glaze over a yellow underglaze. Towards the bottom the brush is used in a horizontal scumbling movement.

Add a quick vertical scumble glaze over the horizontal scumble for a more irregular effect, still letting more of the yellow underglaze show.

A few thicker touches are scumbled to the right. The yellow glaze shows through the green scumble glaze irregularly.

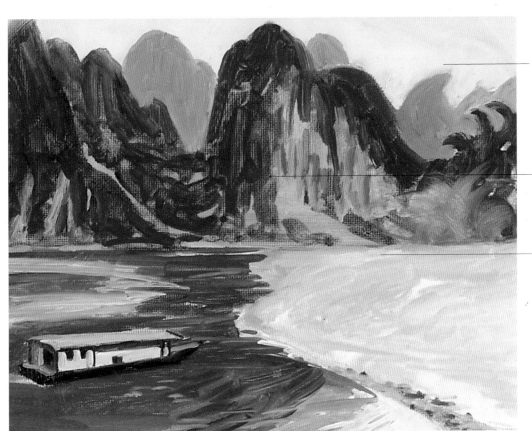

The sky is a single glaze of light blue.

Several glazes partially overlapping each other form the mountains and the water.

The yellow glaze of the beach is scumbled over by a lighter yellow glaze.

Guilin, China This scene is entirely painted in glazes. In some places a single glaze is applied, while in other areas, such as the river, multiple glazes are overlaid.

Mixing with mediums

Apart from thinning the paint with turpentine or odourless thinner, a mix of two parts turpentine and one part oil, or a glazing medium, to make glazes, you can add different mediums to make the paint thicker. This is done by adding thicker mixes of two parts oil and one part turpentine, or by using an alkyd-based painting or impasto medium. An important rule of oil painting is to paint "thick over thin".

USING MEDIUMS

A glazing medium can be used for glazing and blending. Its addition can increase the gloss effect of the paint and help the paint to dry more quickly. For medium thickness painting when you want more expressive brushstrokes a painting medium can be added. An impasto medium can be added to the paint when you require much thicker paint for textural effects.

Glazing medium will thin the paint and create transparency.

Painting medium will thicken the paint for expressive brushstrokes.

Impasto medium will bulk out the paint considerably and add texture.

Violet mixed with impasto medium on the palette becomes viscous and can be applied by brush or painting knife.

PAINT MIXED WITH MEDIUMS

The paint samples below show how paint is altered when mixed with different mediums. The second row of samples have sand added to the mediums for texture.

Paint from the tube usually does not spread easily, and it can adhere unevenly to the surface.

Turpentine makes a thin and transparent colour, but can also result in a rather dull quality.

Impasto medium gives the paint the consistency of egg yolk, making it rich and easy to use.

Turpentine and linseed oil make a glossy medium thickness paint that is easy to work with.

THICK OVER THIN

Remember always to paint "thick over thin". If you do the reverse and apply thin paint over thick paint the thin top layer dries quicker over the slower drying underlayer. When this underlayer dries in its turn it contracts, and causes the hardened top layer to crack and form tiny uneven ridges. You can prevent this by first painting in thin paint and glazes before adding thicker layers of paint. These may be mixed with a painting medium or with mixtures of turpentine and linseed oil. Finally, thick or impasto layers may be added to the painting.

USING THICK PAINT (IMPASTO)

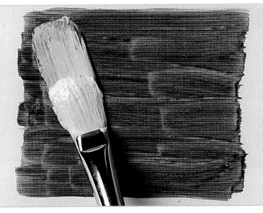

Paint a thin green glaze. Overlay this with a thick yellow paint bulked out with impasto medium.

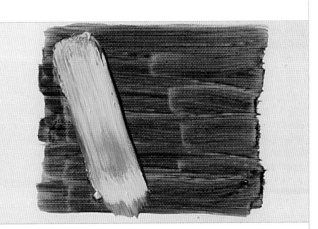

Apply the yellow paint thickly and with a bold stroke. The paint is sticky and runs out quickly showing the undercolour.

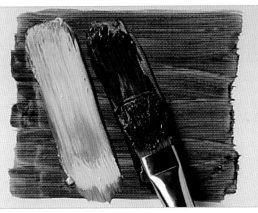

Next paint an impasto violet alongside the yellow. The thick violet paint is viscous and slightly pushes the green aside.

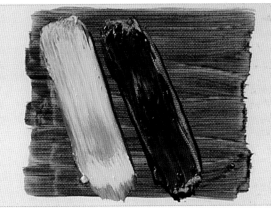

Both colours stand up in ridges and show a variety of thicknesses within the brushstrokes.

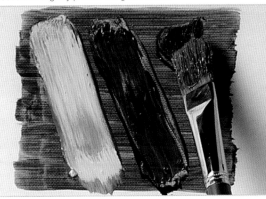

Make a dot of violet next to the two stripes of colour. Push the brush down on to the green and turn it.

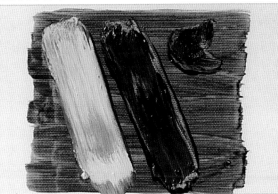

The resulting surface of the dot sticks up as an irregular contrast to the thin green underpaint.

Composition

Composition is the art of arranging the colours and shapes in a painting to convey what excites the painter about a subject. It is about analysing the subject so that each part of the painting is right in itself, in relation to the other elements of the painting, and in relation to the work as a whole. Plan active and complicated areas, but balance these with open and simpler areas to give the eye a rest.

VIEWFINDER

Working with a viewfinder makes it easy to establish a good composition. Cut two L-shaped pieces of card and hold them to make a rectangle that is roughly to the proportions of the support. Look through it at your subject to plan the composition of your painting. Pull the viewfinder closer to your eye and you will see more of the scene before you. Move it to the left and right, or up and down, to vary the scene.

Frame and crop the picture by sliding the corners of the viewfinder.

FORMAT

The composition of your painting also relates to the format or shape of the support. A landscape or horizontal format is suited to views of the countryside or sea, while a portrait or vertical format is suited to the shape of the head and shoulders. A square format allows a flexible composition, which you might prefer for interesting still life arrangements.

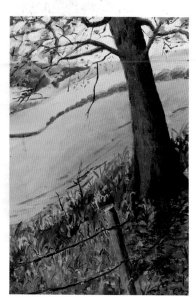

Portrait format The focal points here are the tree and the fence post, which contrast with the tiny shapes of bluebells at the edge of the woodland.

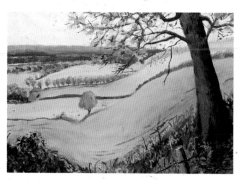

Landscape format The tree leads the eye from the shade into the sunny landscape, across the fields with the single small tree, to the farm buildings on the left.

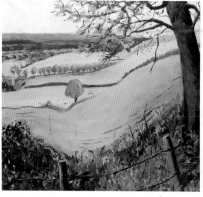

Square format The accent here is on the large tree, and the small tree and diagonal lines in the middle distance.

USING THE RULE OF THIRDS

Decide on the main focus of interest in the painting, and plan another one or two significant points in the scene to lead the eye on a journey through the picture. An easy way of placing the focal points is by using the rule of thirds. Divide a painting equally into three both horizontally and vertically, and place the focal points where the dividing lines cross. This rule of thirds is a help in composing the painting from the outset.

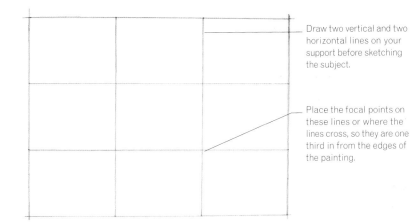

Draw two vertical and two horizontal lines on your support before sketching the subject.

Place the focal points on these lines or where the lines cross, so they are one third in from the edges of the painting.

The man is the largest subject and the darkest tone in the picture plane. He is placed along a vertical line.

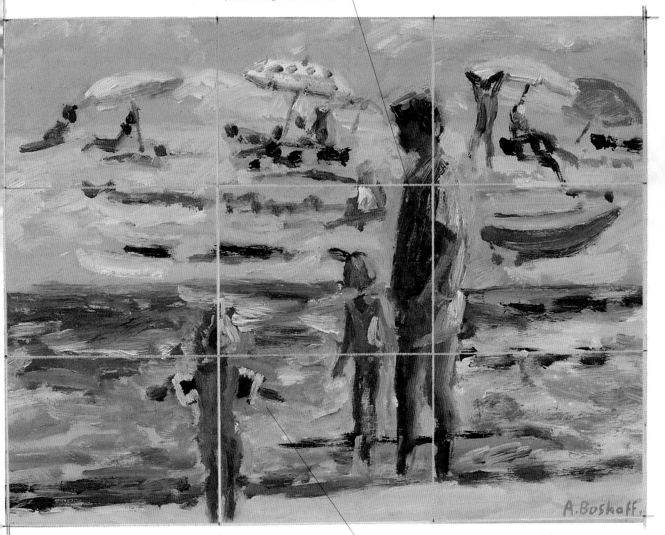

Beach at Great Brak In this painting the eye travels from the jumping smaller child to the father and his watching daughter in the water. The major figures are positioned according to the rule of thirds, making a balanced composition.

The pigtail of the girl and her plastic armbands give just enough detail to attract the eye.

Sketching

Drawing and sketching is an important preparation to painting. Learning to draw is an exciting journey of discovery, and drawing will sharpen your observational skills. In a working drawing you can plan the position of focal points, the proportions, and relationships in the painting, and the perspective if you use one. It may also show the colour key and tonal values of the scene. A sketch may show the development of the thought process of the painter in the planning of the work.

KEEPING A SKETCHBOOK

Most painters keep a sketchbook in which they jot down whatever strikes them in quick sketches. Others make more elaborate studies of what they see, but often you need just a pencil, a scrap of paper, and five minutes to make some marks. Making sketches can be like keeping a visual diary, and the main interests of the artist will show in the sketchbook.

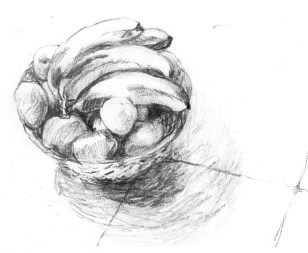

Planning a composition A carefully executed drawing in pencil has included the lines of the tiles on the table top as a compositional device. The drawing would lack something without these carefully drawn lines.

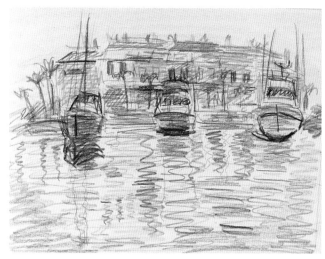

Quick colour sketch The speed of execution of this quick sketch shows an energy and vibrancy, with simple lines, which may not be so easy to achieve in a more elaborately worked painting.

DRAWING IN PENCIL

Pencil is a versatile tool. Artists use softer and blacker B pencils, varying from 2B, the hardest, to 6B, the softest and blackest. Use the point of a pencil to draw fine and precise strokes, or the side of the graphite point for shading and wider marks. Held lightly it creates greyer marks; pressed down firmly blacker marks result. While a pencil drawing can be a valuable work of art in its own right, pencil can also be used for preparatory sketches. Sketching the main outlines of the composition on your support before you begin painting makes the final work that much more assured.

A sketch for the Café scene project (see pp. 92–97) was drawn directly on to the support before painting began.

PLANNING A PAINTING

Plan a painting with one or two preparatory sketches in pencil, crayon, or paint. The sketch can be done on paper as a guideline for the final work, or it can be done on the support itself, to be painted over later. In the sketch you can freely establish the perspective, and the relationships and relative sizes of subjects, without fear of getting it wrong.

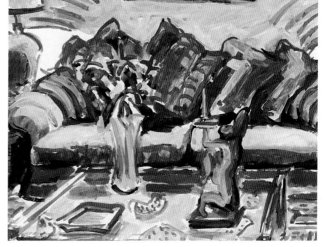

Pencil sketch The overall relationships in this interior are worked out in a line drawing. The scene is drawn with great attention to detail, and the entire picture plane is filled. Use an eraser to improve precision.

Oil sketch The scene is repeated in a quick oil sketch, just using primary colours, and black and white, to work out the different tones. The cushions are worked up in this stage, an idea abandoned in the final work.

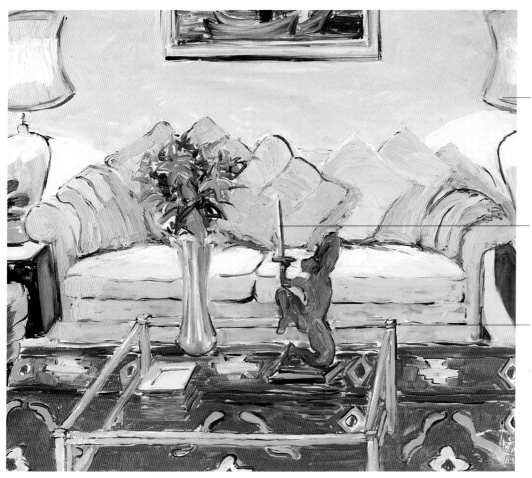

The lights on either side of the sofa give off a soft light on the walls, lampbases, and sofa.

The flowers, vase, ashtray, and sculpture of Zeus holding a candle are focal points.

The glass table and the pattern in the rug are treated simply.

Final painting After the two preparatory sketches the scene can be put down with confidence. The colours and tones are simplified. The cushions and the shapes in the rug form a harmonious rhythm.

Preparation and finishing touches

Prepare yourself thoroughly for a painting session so that you are not held up once you start painting. The act of getting ready also helps to put you in the right mood for painting. You need a table that is large enough to hold your palette, paints, brushes, painting knives, mediums, and other painting equipment. Place your support on an easel if possible, and avoid placing the subject in direct sunlight as the light may change considerably before you can finish your painting.

Light Make sure that natural light hits the surface of the support. Do not work in your own shadow.

Subject Have an unobstructed view of your subject so you do not have to move to see it. Paint it against the light rather than in direct sunlight.

Palette Have all your colours ready squeezed from the tubes on to the edge of the palette.

Easel Use an easel to hold the support up vertically. Position it so that you can step back while painting to get an overview.

Brushes Place brushes upright in pots while painting. Use one for clean brushes and the other for used brushes with colours you want to come back to.

Turpentine and linseed oil Keep them near at hand to use pure or in mixtures from thin to thick.

Painting table Keep your painting table below your hand so you can reach the palette without moving.

Dipper Keep the dipper clipped on to the palette or close to it, and fill the holders with the mediums you need.

VARNISHING

Leave the painting where it can dry undisturbed. It can take a day to a few weeks for the painting to become hand dry, and up to three to six months to harden off completely. When the painting is thoroughly dry you can varnish it to protect it against dust and to enrich the paint surface. Varnish is available in matt or gloss finishes. Use a primer and varnishing brush, and cover the whole surface of the painting, working from left to right and from top to bottom.

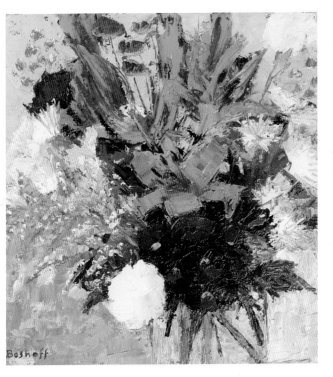

This part of the painting is unvarnished. The lean underlayer looks more matt than the fat impasto layer on top of it.

After varnishing, this part of the painting has a consistent gloss sheen. The varnish covers ridges and crevices alike, and protects against the ravages of time.

Varnish is transparent and provides a removable film of protection to the painting surface. The right half of this work is varnished with gloss varnish. The left half is as yet unvarnished.

FRAMING

A well-chosen frame greatly enhances a painting. For small oil paintings choose a frame with a width of about 2.5cm (1in). Larger paintings need a frame that is at least 5 or 7.5cm (2 or 3in) wide. A slimmer frame may look insubstantial. Choose a frame by holding a sample corner frame on every corner of the painting to see the result. The colour of the frame should match some colour in the painting, or relate harmoniously to the work.

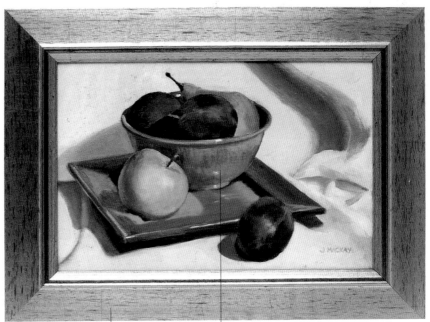

The wood frame relates well to the natural subject of this still life picture, and enhances the colours in the painting.

The colour of the light wood harmonizes with the golden fruits.

The blue ceramic bowl and dish are emphasized by the contrasting frame.

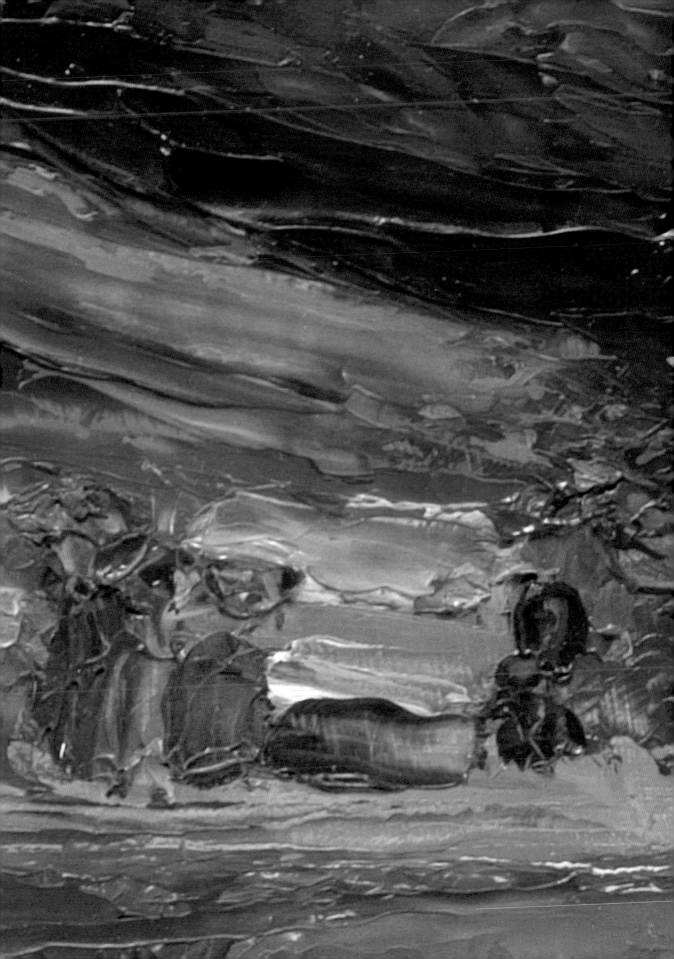

"Express yourself with texture: juxtapose translucent glazes with thick, tactile paint."

Textural effects

One of the most exciting aspects of painting in oils is the wide range of textures that you can create. You may choose to express your feelings about your subject by slowly building up thin glazes, so that you achieve a smooth, subtle finish from the cumulative effect of layers of paint; at the other end of the scale, you may wish to make urgent, spontaneous marks with thickly laid paint to create a tactile, heavily textured surface. The approach you use will influence the viewer's response as much as the subject itself.

FROM GLAZES TO IMPASTO

Laying a series of transparent glazes that allow underlying colours to glow through each successive application creates a translucent and refined work. Impasto painting, where the pigment is applied thickly to the surface, has a very different, sculptural result. This may be done alla prima (meaning in one go), with thick paint throughout, or begun with medium-thick paint and finished with a thick and varied layer of marks made by a brush, painting knife, fork, or comb. Directional marks will draw the viewer's attention across the canvas, helping to guide the eye to your point of focus. Adding sand, sawdust, marble dust, or plaster to the paint gives extra texture.

The white of the support shines through the thin glaze, giving it translucency.

The raised edges of the strokes of thick-textured impasto paint are clearly visible.

DIFFERENT EFFECTS

The three illustrations below show how the same scene can take on a different emphasis, depending upon the technique you use to apply the paint to the surface.

Laying thin glazes

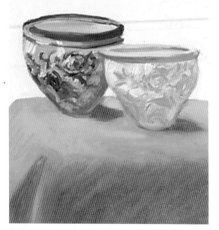

Using a series of thin glazes to paint all the objects gives a smooth surface.

Combining thick and thin

The light table top, pots, and background consist of thicker paint, giving a variation of texture.

Painting impasto

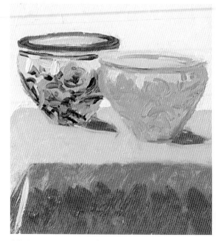

All the elements are painted impasto, the texture showing the malleability of the pigment.

VARYING THE TEXTURE

While you may wish to create a painting entirely from glazes or impasto, the majority of oil paintings are created with a mixture of surfaces in order to provide interesting textural contrasts. The juxtaposition of translucent glazes with thickly applied, even three-dimensional, paint provides another element of painting to hold the viewer's attention, the quality of the surface becoming as important to the painting as a whole as the use of tone and colour.

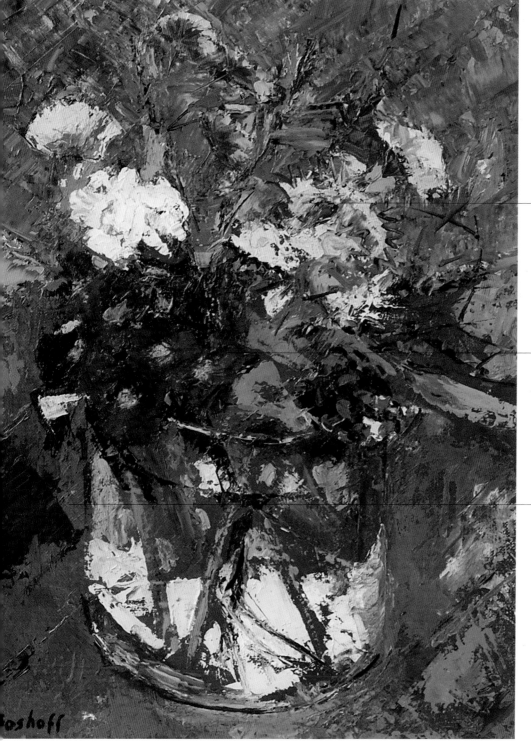

The bright colours of the flowers, foliage, and background have been ladled on thickly with a painting knife.

The darker areas in the flowers and foliage have been painted thickly with the brush.

The picture is underpainted with dark olive green, which is left uncovered in places.

Flowers in a vase This picture shows thin glazes and impasto used together in the same painting.

Gallery

Oil paint allows the artist to explore a range of textures, from the smoothness of translucent glazes to the rugged effects of impasto.

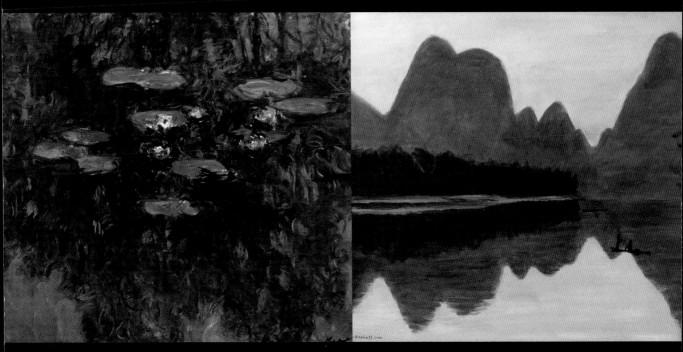

▲ Waterlilies

The heavily textured mark-making is abstract seen at close range, with recognizable forms appearing as the viewer moves further away from the paint surface. *Claude Monet*

▲ Guilin

The silhouetted mountains and their reflections in the river are rendered with several translucent glazes of blues and lilacs from within a narrow colour range. *Aggy Boshoff*

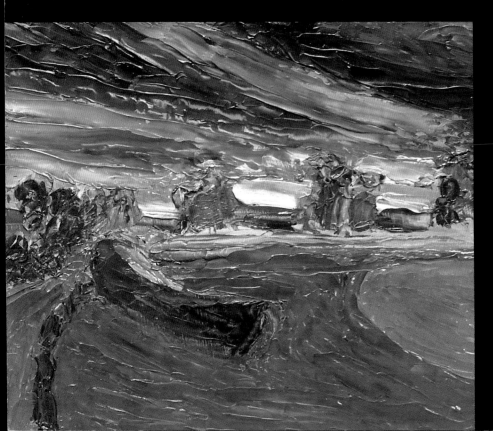

◄ Boat, Bembridge

The marks of a painting knife draw attention to the thick paint surface. The light catches the bottom rims of the clouds, casting the tops in deeper shadow to increase the impression of stormy weather. *Brian Hanson*

Apples on a white plate ►

The apples in this painting are built up from small, thickly applied, abstract touches of different colours. Though they are not blended together, from a distance the impression is of smooth, shiny fruit. *Wendy Clouse*

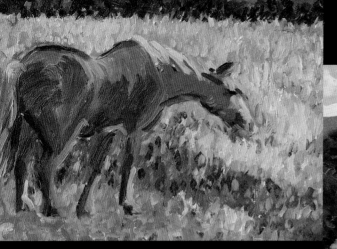

▲ Sam

The pony is painted against a backdrop of vivid, short strokes laid thickly in a hatching pattern. The brushstrokes on the animal are longer, describing the roundness of his flanks. *Aggy Boshoff*

Dartmoor study ▶

The painting is built up of layers of thin and medium-thick paint. The foreground foliage and base of the trees have been scratched into, and the fields are scumbled with green over a yellow underlayer. *Christopher Bone*

⬜1 Beach with parasols

In this tropical beach scene the three main areas of the sky, sea, and beach are each worked up with several layers of colour. Overlaying glazes are used to establish an intensity of colour and produce a shimmering quality that characterises bright sunlight. The paint is applied thinly, but the brushstrokes are expressive. Subtle scumbling is used to suggest the texture of the sandy beach, while the expanses of sea and sky are created by softly blending layers of paint wet-in-wet. Only the later additions to the clouds are painted more thickly to give volume.

EQUIPMENT
- Oil painting paper
- Brushes: No. 2 round, No. 8 and No. 10 flat, No. 4 and No. 6 filbert
- Cotton rag
- Turpentine or odourless thinner, glazing medium, painting medium
- Prussian blue, titanium white, cerulean blue, cobalt turquoise, yellow ochre, cadmium yellow, alizarin crimson, cadmium red, ultramarine blue, lemon yellow, burnt sienna, cobalt blue

TECHNIQUES
- Glazing
- Wet-in-wet

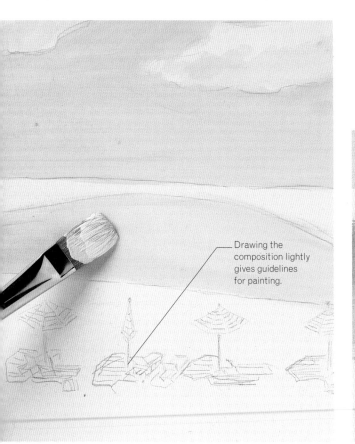

Drawing the composition lightly gives guidelines for painting.

Using the paint wet-in-wet makes it easier to blend.

1 Mix Prussian blue and titanium white with turpentine. Paint the sky with broad strokes using the No. 10 flat brush, leaving the white clouds. Glaze the mix over the lightest part of the sea. Add more titanium white to the mix for the cloud bases.

2 Mix cerulean blue, cobalt turquoise, titanium white, and turpentine. Glaze the mid sea area using the No. 8 flat brush. Work this turquoise mix wet-in-wet into the edges of the lighter areas of the sea, and into the clouds.

BUILDING THE IMAGE

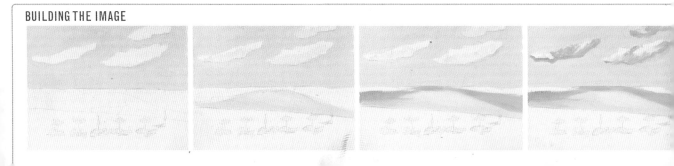

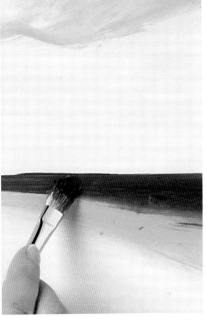

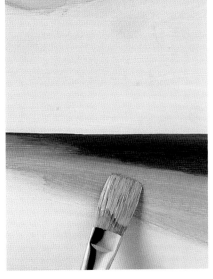

3 Mix Prussian blue and glazing medium. Glaze the darkest areas of the sea towards the horizon with the No. 4 filbert brush. Use light horizontal strokes, mixing with the mid colour of the sea.

4 Mix Prussian blue and the turquoise mix with glazing medium to blend the mid and dark colours. Add titanium white to scumble into the clouds. Mix Prussian blue, titanium white, and glazing medium for the mid area.

5 Scumble in the clouds with the mid sea glazing mix. Mix titanium white, glazing medium, and turpentine to scumble the lightest area of the sea, and paint the tops of the clouds with the No. 6 filbert brush.

6 Use the turquoise mix with glazing medium rather than turpentine to paint the top of the sky and to define the tops of the clouds. Increase the amount of cobalt turquoise in the mix as you progress further down towards the horizon.

7 Add some turpentine to the turquoise mix to thin it. Paint the shadow sides of the parasols with the No. 2 round brush. Rub off some of this paint with a clean rag. Use the paint on the rag to add other shadows behind the loungers.

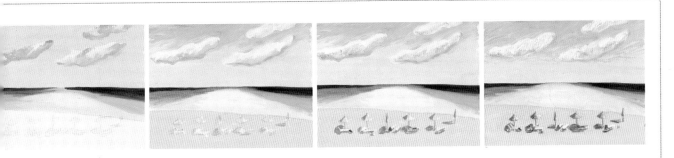

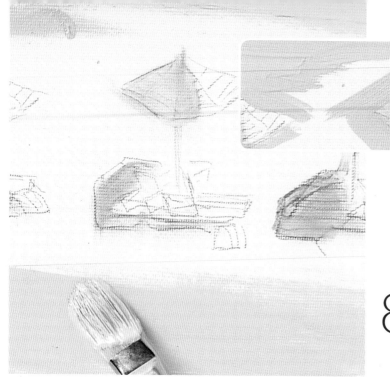

8 Mix yellow ochre, titanium white, and cadmium yellow with turpentine. Paint the beach with the No. 8 flat brush with long light strokes. Work around the parasols and loungers using the No. 2 round brush. Lightly touch the sea with this mix, and the parasol sides in the sun.

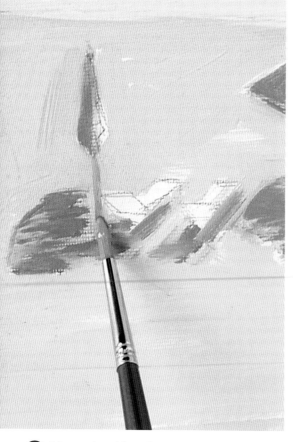

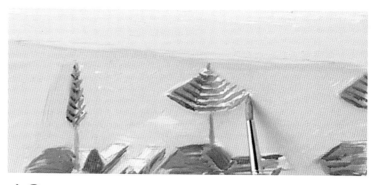

10 Paint the bags and towels with a thin mix of cadmium red and turpentine. Mix ultramarine blue with turpentine to make some of the shadows cooler. Use this mix for the shaded stripes of the parasols, adding cobalt turquoise for the mid blue stripes. Paint the stripes in the sunshine with cobalt turquoise and turpentine. Use titanium white and turpentine for the white stripes.

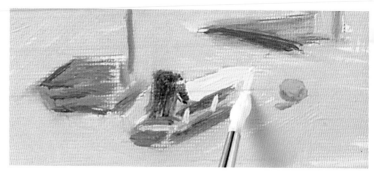

9 Mix cerulean blue, alizarin crimson, titanium white, and yellow ochre with painting medium. Add to the shadows on and under the parasols, and under the loungers. Add parasol stands. Lightly add some of the shadow mix to the clouds.

11 Add lemon yellow to the white stripe mix to paint the loungers. Mix cadmium red and cadmium yellow to enliven the shadows and paint the beach ball. Add more cadmium red for shadow on the ball. Paint the parasol stands in the sunlight with burnt sienna and turpentine, and add some of this colour to the shadows.

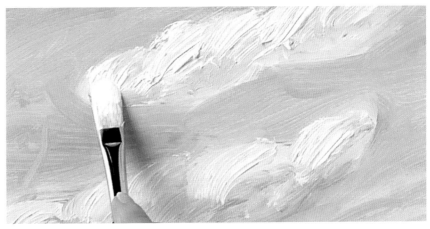

12 Mix cadmium yellow, turpentine, and painting medium. Scumble this mix over the beach with the No. 6 filbert brush. Add this colour to items on the beach, and dash lines into the sea.

13 Add cobalt blue to the turquoise mix with glazing medium. Paint the top of the sky and add to the clouds. Scumble titanium white with glazing medium over the sea and add patches to the clouds.

▼ Beach with parasols

Varied yellows and blues unify the different elements. Working on parasols and loungers as a group prevents too much detail, but soft shadows and colour accents add life.

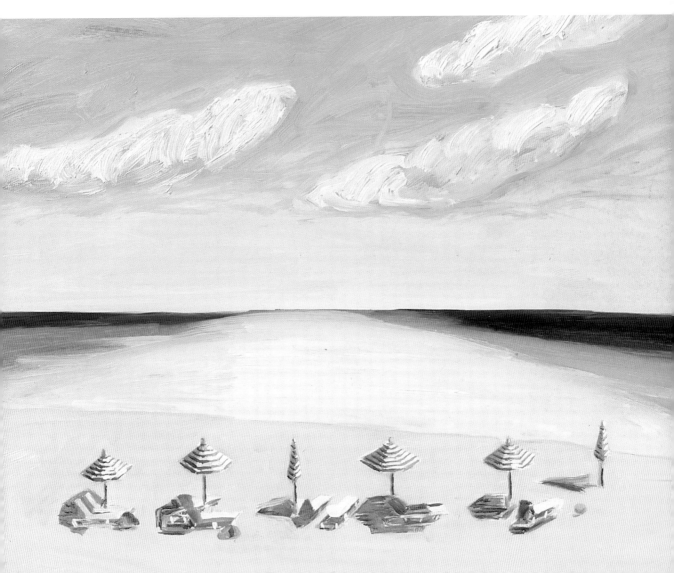

2 Forest stream

The forest setting for this painting is a tangle of leaves and branches, cut through by a stream that runs along its floor. The scene is unified by starting the painting with two very thin glazes of colour. Thicker paint applied on top of the glazing in small strokes or dabs gives texture to the foliage of trees and undergrowth. By keeping the larger shapes of the bushes and trees in mind while painting, the distraction of precise detail is avoided. The repetition of the branches curving over the stream creates a subtle rhythm.

"Apply an underglaze for instant colour in a painting."

EQUIPMENT
- Canvas
- Brushes: No. 2 round, No. 4 filbert and No. 8 filbert
- Cotton rag
- Turpentine or odourless thinner, glazing medium, impasto medium
- Burnt sienna, Prussian blue, cobalt turquoise, raw sienna, ultramarine blue, cadmium red, yellow ochre, alizarin crimson, raw umber, titanium white, sap green, viridian green, cadmium yellow, ivory black, lemon yellow, cobalt blue

TECHNIQUES
- Glazing
- Drybrush

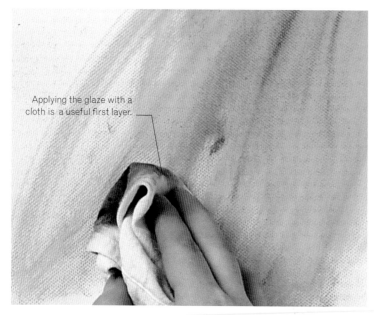

Applying the glaze with a cloth is a useful first layer.

1 Mix burnt sienna and turpentine, and apply this glaze to the areas of woodland, using a cloth and sweeping movements. Mix Prussian blue and cobalt turquoise to create a background glaze for the sky and water.

2 Mix raw sienna, ultramarine blue, cadmium red, and yellow ochre. Lightly paint the main trunks and branches using the No. 4 filbert brush. Add more ultramarine blue to the mix for definition.

BUILDING THE IMAGE

3 Add alizarin crimson and raw umber to the bluer tree mix. Use the No. 8 filbert brush to roughly sketch in more branches and the riverbank. Add some titanium white to paint in variations on the forest floor and local colour among the trees. Drybrush with rough brushstrokes.

4 Mix sap green, viridian green, titanium white, some of the sky mix, and turpentine. Paint the foliage with short horizontal and diagonal strokes using the width of the No. 8 filbert brush. Add more sap green, viridian green, and cadmium red to the mix, and drybrush the shaded areas.

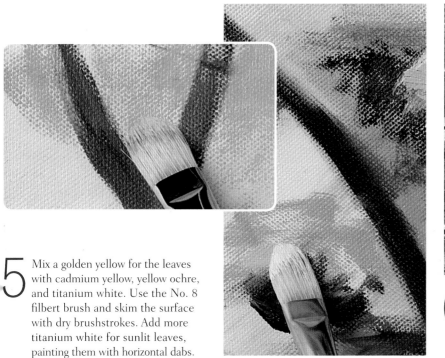

5 Mix a golden yellow for the leaves with cadmium yellow, yellow ochre, and titanium white. Use the No. 8 filbert brush and skim the surface with dry brushstrokes. Add more titanium white for sunlit leaves, painting them with horizontal dabs.

6 Accentuate the lines of the trees and the undersides of the rocks with an ivory black, lemon yellow, and raw umber mix. Use the No. 2 round brush lightly to do this.

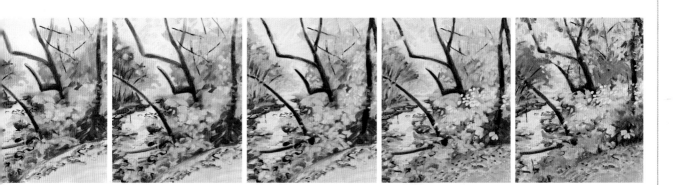

7 Add more titanium white and cobalt turquoise to the sky mix, with less turpentine so it is thicker. Dab over the sky and among the leaves. Add titanium white to paint in sunlight.

8 Mix ivory black, viridian green, and raw umber to define the branches. Add lemon yellow for a mid green and dab in crescent moon shapes among the main foliage.

9 Mix cadmium yellow and cadmium red, and scumble the foreground. Add alizarin crimson to the sky mix for lilac pebbles. Add painting medium to this lilac mix to tone down areas.

FOLIAGE

Do not worry about painting the precise details in a mass of foliage. Textured dabs of colour can suggest the moving shapes of falling leaves.

10 Mix lemon yellow and titanium white with plenty of glazing medium. Use the No. 2 round brush to dab patches of light into the darker areas. Mix impasto medium with cadmium yellow to paint thicker dabs of colour.

11 Mix cobalt blue and alizarin crimson with glazing medium. Use this mix to paint some shadow areas. Paint darker foliage with a mix of sap green, viridian green, and cobalt blue. Use the thick yellow mix from step 10 to add more highlights.

Forest stream ▶

This painting is underpinned by glazes that hold the larger masses of foliage together. Varied brushstrokes using drybrush, and dabs of thick and thin paint, worked over the whole scene, add interest to the surface.

3 Red pears

This painting of luscious pears shows how the addition of an impasto medium can be used to thicken oil paint and increase its textural possibilities. Layer upon layer of paint is used to create the pears, using a brush or a painting knife so that the paint stands up in thick ridges. Sometimes the underlying colour gets dragged into the top paint, but this simply adds to the expressiveness of the brushstrokes. A final overpainting of the fruit with glazing medium added to the paint makes the red of the pears look even stronger.

EQUIPMENT
- Primed hardboard
- Brushes: No. 2 round, No. 8 and No. 12 flat, No. 8 filbert, No. 6 fan
- Painting knives: No. 21 and No. 24
- Glazing medium, linseed oil, impasto medium
- Brilliant pink, rose madder, alizarin crimson, viridian green, sap green, ultramarine blue, titanium white, lemon yellow, cadmium yellow, transparent yellow, Prussian blue, cerulean blue, yellow ochre, burnt sienna, cadmium red, magenta

TECHNIQUES
- Impasto
- Painting knife

1 Draw the pears, marking in the highlights and shadows. Mix brilliant pink, rose madder, and linseed oil. Paint the pears with the No. 8 filbert brush, leaving out their shadowed areas. Add alizarin crimson to the mix for the shadowed areas.

BUILDING THE IMAGE

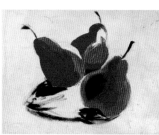
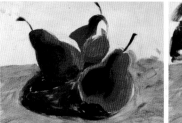
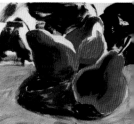

2 Mix viridian green, sap green, ultramarine blue, alizarin crimson, and titanium white with linseed oil for the cast shadows, and for the dark areas and stalks of the pears. Add lemon yellow for lighter shadow areas. Add cadmium yellow and ultramarine blue to the cast shadow mix, and work into the light and dark areas to knit them together.

3 Use the No. 12 flat brush and combine transparent yellow and viridian green with impasto medium to paint in the rest of the foreground. Use bold horizontal and diagonal brushstrokes for variety and texture.

4 For the background wall add Prussian blue, cerulean blue, and titanium white to the cast shadow mix from step 2. Apply with the No. 21 painting knife for precision around the pears. Fill in the larger areas with the No. 12 flat brush.

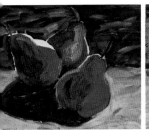
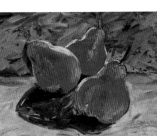
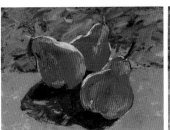
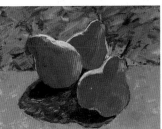

5 Mix yellow ochre with burnt sienna and paint the light side of the stalks with the No. 2 round brush. Repaint the darker shadows on, and cast by, the pears with cadmium red and yellow ochre, toned down with some of the background mix from step 4.

6 Mix cadmium yellow and viridian green, and work into the background. Mix cadmium yellow, cadmium red, and magenta for the pears' mid tones. Use cadmium yellow, cadmium red, and lemon yellow for the lighter areas.

7 Use the No. 21 painting knife to apply lemon yellow highlights on the other pears. Mix brilliant pink, titanium white, and cadmium yellow. Apply to the lightest parts of the pears, using the No. 24 painting knife, for highlights on the edges.

8 Add titanium white to the green foreground mix and apply with the No. 21 painting knife all over the background wall to lighten. The background now appears to be subtly lighter than the pears.

9 Use some glazing medium mixed with cadmium red to make a thin glaze. Add this over the existing colour of the pears, gently dragging the colour over the top of the thicker paint with the No. 6 fan brush.

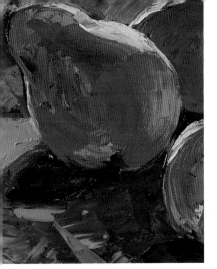

SCRATCHING IN

If you start to lose the crisp outlines of an object against the background, use the wooden end of the brush or painting knife to scratch them back in.

10 Mix viridian green with sap green and blend under the pears using the No. 21 painting knife. Mix sap green, viridian green, and cadmium yellow with impasto medium for the foreground.

11 Mix magenta with glazing medium to add blushes on the pears using the No. 6 fan brush. Use the No. 24 painting knife to add highlights with a mix of titanium white, brilliant pink, and lemon yellow.

▼ Red pears

This simple composition of three red pears throws the accent on the paint surface. The red fruit contrasts with the green background, and this combined with the use of texture makes the pears look almost sculptural.

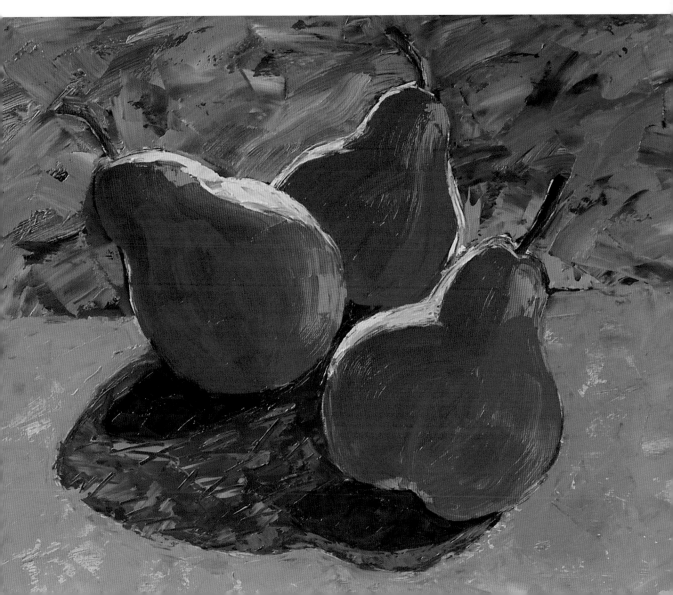

Colour

"Plan your palette to create a vibrant and harmonious painting ."

Choosing your palette

To create a really vibrant painting you need to plan your colours carefully. You may decide upon a highly coloured approach, or a painting in which brighter colours are set off by more neutral ones. You must also consider the relative lightness and darkness of your colours, so that if you were to photocopy your painting in black and white you would still see a pleasing balance in the composition. Look, too, for complementary colours that you can juxtapose to emphasize their brilliance and harmony.

COMPLEMENTARY COLOURS

Decide upon the colour palette you want to use before you start to paint, to make sure you have an overall unity in your work. Colour contrasts make each colour look brighter and the painting will become immediately more appealing to the eye; a red, for instance, will look a more brilliant red because you have made its shadow greener. The colour contrasts of the three sets of complementary colours – yellow-violet, red-green, and blue-orange – in particular have this effect because these colour combinations appeal most to our innate sense of harmony.

Blue-orange

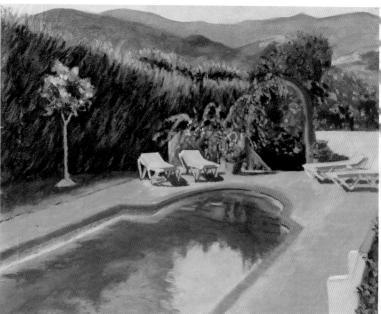

The pool's turquoise colour really sings out because of its juxtaposition with the orange terrace.

Red-green

If you hold one hand over the green of the lime you will see that the painting really loses interest and vibrancy without it.

Yellow-violet

The shadows are painted more blue and violet than they were in real life to form a foil for the yellow of the flowers.

TONE

Tonal balance is as important as colour balance, so you need to analyse the tonal values of your colours. "Tone" refers to the relative lightness or darkness of a colour, which can be altered by mixing it with another colour or with black or white. You can judge tonal values more easily by half-closing your eyes, which effectively banishes colour in favour of tone. You will soon see if your composition is tonally unbalanced, for example with a preponderance of dark tone in just one area.

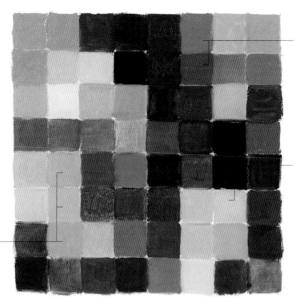

This red and green are too close in tonal value to enliven each other.

Here there is an extreme contrast of tone.

This trio of colours forms a single block of similar tone.

In this colour chart, some adjacent colours raise each other's intensity. Others are so close in tone they appear dull and flat.

COLOUR MIXING

The paintings shown below demonstrate two different ways of varying the tone of colours. In the left-hand painting, the colours have been mixed with black or white. In the right-hand picture, the colours have been modified by mixing them with darker and lighter colours. Note how a dark tone appears even darker when placed next to a light tone.

A harmonious effect can be created in paintings by using complementary colours. Where they are juxtaposed the colours gain extra vibrancy.

Cockerel and chicken ▶

The greens of the grass and foliage throw the brilliant oranges and reds of the chickens into sharp relief. Touches of violet in the background foliage complement the yellow of the daffodils. *Julie Meyer*

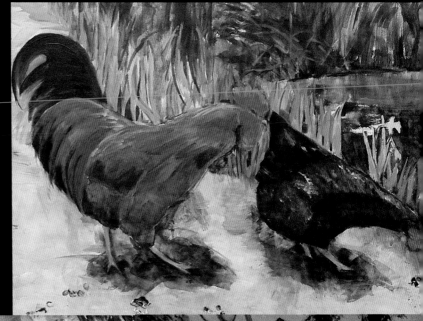

▼ Girl in wood

The scene consists of a variety of greens, which are balanced by the red of the dress and the many touches of red throughout the scene. The colour of the path also has reddish-pink in it. *Aggy Boshoff*

▲ Les dindons

While the palette in this painting is more subdued, it too is based on the harmony of red and green. Pink is used extensively in the buildings, and there are touches of orange in the foreground and middle distance. *Paul Gauguin*

◀ Still life with blue pottery

Two pairs of complementary colours are used here to great effect. The yellow apple acts as a foil for the purplish plums, while the pear has an orange hue to balance the blues. *Jennifer Windle*

▼ Magenta tulips

The strong magenta of the tulips is a cool red with a hint of blue in it. The acid green of the background and the bluish -green of the leaves together counterbalance this colour effectively. *Aggy Boshoff*

▼ Flowers

Here the orange of the fruit is intensified by its proximity to blue, its complementary colour. The use of a second set of complementary colours, red and green, adds to the overall harmony of the work. *Samuel John Peploe*

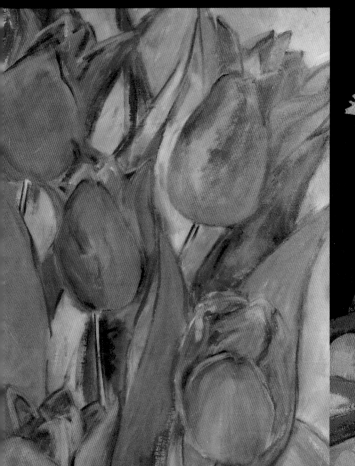

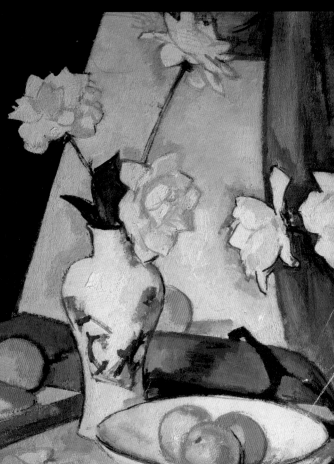

4 City river

Four different tones of blue are used in this calm painting of an urban river and its many bridges. The sky, the water, and the different hills are all painted with Prussian blue with either black or white added to create the various tones. This tonal colour mixing produces a range of colours so that contrasts through the painting can be established. The sky and water are the lightest tones after the light buildings, and contrast with the repeated shapes of the darker bridges. The paint surface is built up gradually so that the tonal relationships can be easily adjusted.

EQUIPMENT
- Oil painting paper
- Brushes: No. 2 round, No. 8 flat
- Painting medium, impasto medium
- Prussian blue, titanium white, ivory black, lemon yellow, cadmium red, cadmium yellow, yellow ochre, lemon yellow, viridian green, alizarin crimson, cobalt turquoise, burnt sienna, ultramarine blue, raw sienna

TECHNIQUES
- Blending
- Scumbling

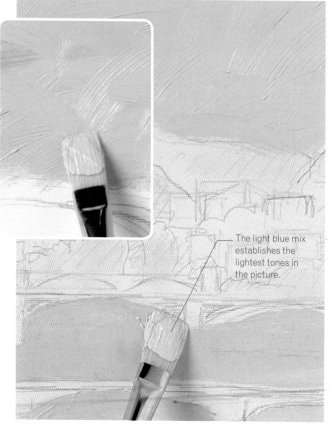

The light blue mix establishes the lightest tones in the picture.

"A limited palette can look colourful too."

1 Paint the sky with a light blue mix of Prussian blue and titanium white with impasto medium. Use the No. 8 flat brush, making broad strokes. Paint the light areas of water in the same mix, and the side of the building that is the same tone.

2 Add ivory black to the sky mix to darken it. Paint the distant hills, blending them softly into the sky. Use this colour for shadows under the bridge, blending them into the water, and scumble the darker areas of the bridge.

BUILDING THE IMAGE

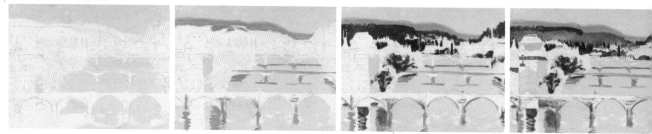

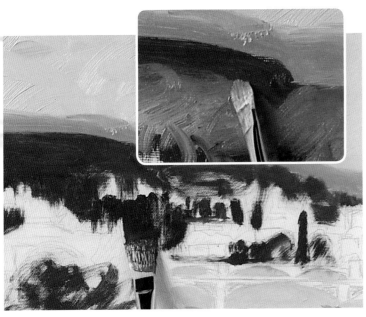

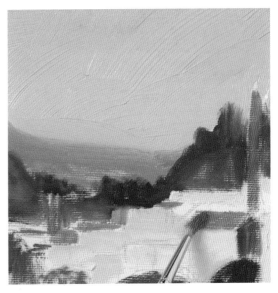

3 Add more ivory black and Prussian blue to the mix. Paint the closest hills and suggest the trees with vertical strokes. Bring the colour down by the buildings and paint the darkest water reflections. Use the step 2 mix to lighten some of the hills and trees.

4 Mix lemon yellow, titanium white, and painting medium for the distant buildings. Mix a soft red from cadmium red, cadmium yellow, yellow ochre, and painting medium to paint the roofs and chimneys using the No. 2 round brush.

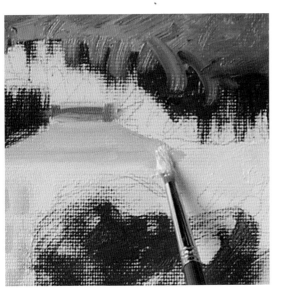

5 Mix lemon yellow and titanium white to paint some buildings on the left. Add a little Prussian blue to the mix for other buildings. Add viridian green to this mix for roofs and the church spire.

6 Paint the shadow side of some buildings with a soft lilac mix of titanium white, alizarin crimson, and Prussian blue. Use this lilac mix in places on the bridges – which look lighter the further away they are.

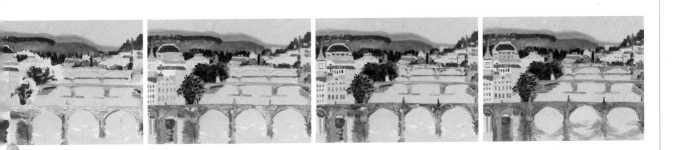

7 Mix alizarin crimson, Prussian blue, and ivory black for the domed roof on the left. Lighten this mix with titanium white for the roof in front of it. Paint the roof of the front building and detail on the spire with cobalt turquoise. Blend a mix of titanium white and Prussian blue to vary other buildings.

8 Mix viridian green, lemon yellow, and titanium white to soften the trees. Add their reflections in the water with horizontal strokes. Make a mid green by adding burnt sienna, then add ultramarine blue for the darkest areas of the trees, keeping the trees on the right lighter.

9 Mix cadmium yellow, titanium white, and painting medium for the edges of the domed roof. Paint windows on the front buildings with the light blue from step 2 mixed with painting medium, and a mauve mix of alizarin crimson, Prussian blue, titanium white, and painting medium.

10 Scumble the mauve mix over the first bridge and put in the statues on the bridge. Scumble a darker mix of Prussian blue and ivory black over the bridge and paint the shadows of the arches.

11 Mix raw sienna and burnt sienna to paint detail on the other bridges, and windows on the domed building. Add more burnt sienna to the mix and paint some stone detail on the front bridge.

12 Mix cadmium red, yellow ochre, titanium white, and painting medium. Paint the clock hands, and scumble the mix over the bridge. Paint a mix of Prussian blue, ivory black, and titanium white with a touch of viridian green under the first bridge to emphasize its reflections.

▼ City river

The cool variations of blue have been counterbalanced by the red of the roofs and chimneys, the warm yellow of the buildings, and the stone colours of the bridges. Effective use of tone creates areas of light and dark, and subtle contrasts.

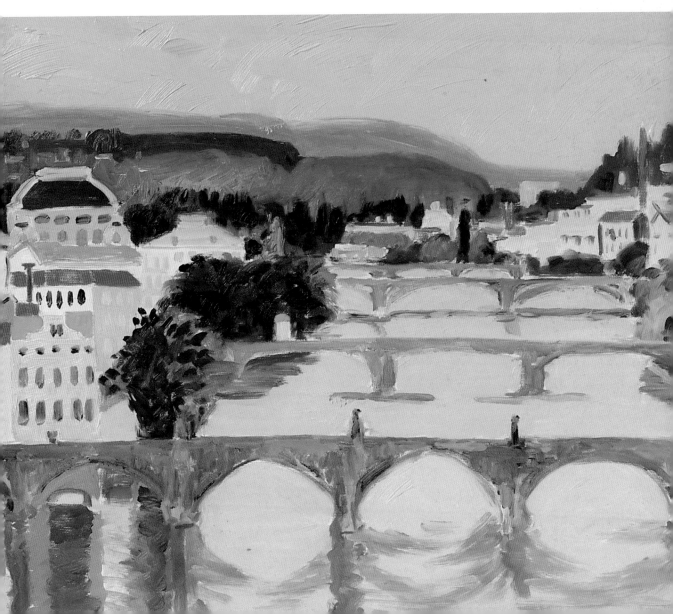

5 Farmyard goats

This country scene of two goats in a farmyard is based on the simple colour contrast of blue and orange – complementary colours. The shapes of the cool blue shadows cast by the background walls and the goats counterbalance and emphasize the orange hair of the goats brightened in the sunlight. The goats are highlighted with a pinkish white that is also used on the cobblestones in the foreground. To balance the blues and greys even more, a warm red is used in the dark background on the vague shape of the pig and in the depths of the pen.

EQUIPMENT

- Canvas
- Brushes: No. 2 round, No. 12 flat, No. 6 filbert, No. 6 fan
- Painting knives: No. 24
- Turpentine or odourless thinner, impasto medium
- Cobalt blue, titanium white, yellow ochre, ivory black, alizarin crimson, burnt sienna, cadmium red, viridian green

TECHNIQUES

- Scumbling
- Painting knife

Shadow under the goats links to the colour used for the wall shadow.

1 Paint the wall with a bluish mix of cobalt blue, titanium white, yellow ochre, and turpentine using the No. 12 flat brush. Add ivory black to the mix to paint the shadows on and under the wall. Add a bit more cobalt blue to the mix for shadows under the goats and some cobblestone detail.

2 Mix a bluish black, using a lot of ivory black with a little cobalt blue, and use the No. 6 filbert brush to paint the dark shadows behind the goats and the gaps between the cobblestones. With the same black mix paint the post and the door of the pen in the background.

BUILDING THE IMAGE

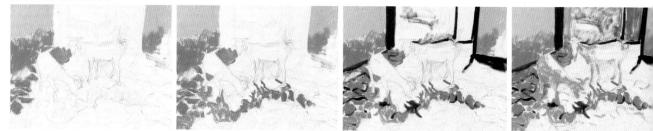

3 Paint the mid tone areas of the goats with a mix of yellow ochre and titanium white, using the No. 6 filbert brush. Add some of this colour to the wall on the left and to the cobblestones. Darken the walls behind the goats with the bluish mix from Step 1 with added ivory black.

4 Mix a warm dark brown from alizarin crimson, burnt sienna, and ivory black to add warmth to the background and to the wall on the right side, which is in the shade. Use this mix to roughly paint the darkest areas of the goats using the No. 6 filbert brush.

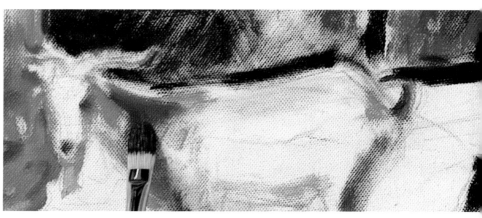

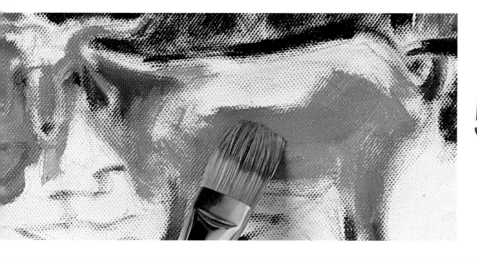

5 Add cobalt blue and a little titanium white to the brown mix from step 4 to add variety to the dark areas of the goats. Paint the shadows on the sides of the goats with the bluish mix from step 1 mixed with some ivory black, and put a stroke along the middle of the face of the rear goat.

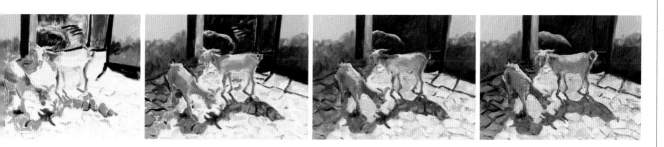

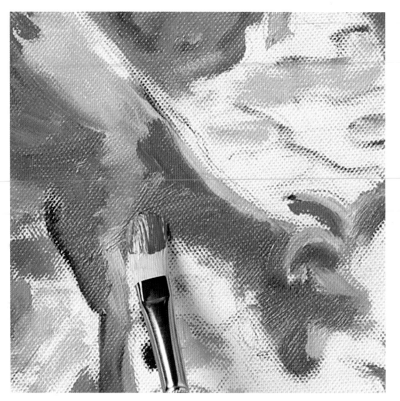

6 Mix impasto medium, titanium white, and a little yellow ochre for the goats. Scumble this yellow mix over the stones too. Add burnt sienna to the mix to darken areas of the goats' hair with the No. 6 filbert brush.

7 Mix titanium white with a tiny amount of cadmium red and use this light pink mix to create highlights on the cobblestones next to the goats, and to add some warmth to the foreground. Apply the colour with the No. 24 painting knife, which helps to create the angular shape of the individual cobblestones.

"Keep working around the painting, modifying colours and shapes again and again."

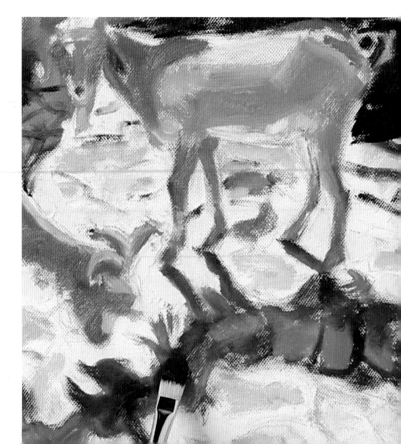

8 Mix viridian green, alizarin crimson, and ivory black and use this to increase the contrast of the shadows on the wall. Use this mix in the background, and shape the pig using the No. 6 filbert brush. Mix ivory black and alizarin crimson to refine the shape of the goats. Scumble this mix in the shadows under the goats.

9 Mix a dark reddish brown from alizarin crimson, ivory black, and viridian green. Use this mix and the No. 6 fan brush to paint the darkest shadows on the goats, and the lighter areas of the pig. Scumble this mix over the background too.

10 Mix cobalt blue with alizarin crimson and titanium white, and use this to add variety to the mid tones on the goats and the blue shadow areas. Scumble the mix on the cobblestones, and use it to outline the shadows.

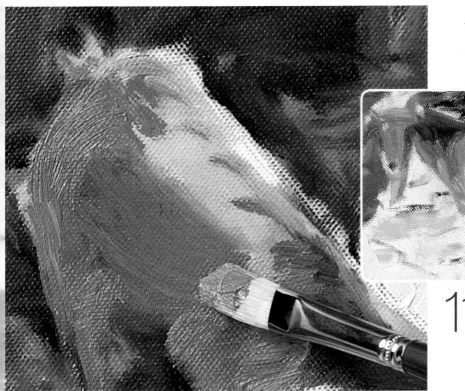

11 Add more variety to the mid tones of the goat at the front with a light orange mix of yellow ochre, burnt sienna, and impasto medium. Scumble the light pink mix from step 7 on the goat at the back where there is reflected light.

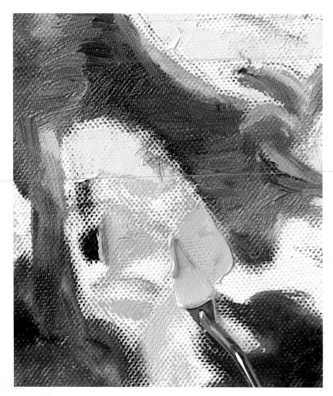

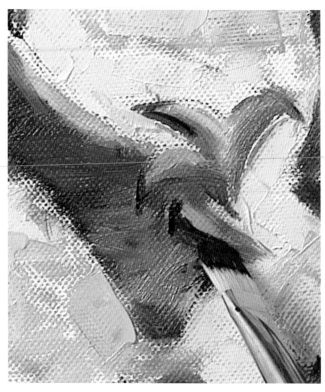

12 Mix titanium white with a little more cadmium red than used in Step 7, and paint the cobblestones with the No. 24 painting knife. Vary the cobblestones with a mix of yellow ochre, the mix from Step 10, and titanium white.

13 Use the dark reddish brown mix from Step 9 to add detail to the goats' heads and in the cobblestones. Strengthen the light cobblestones by using the painting knife to scrape out some light pink and yellow mixes.

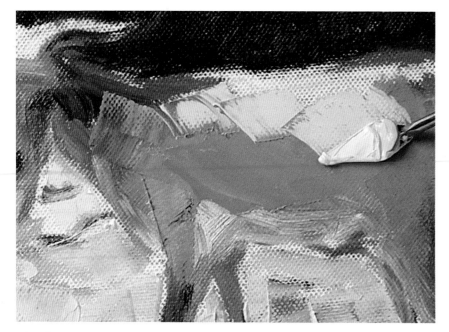

14 Mix a greyish blue from cobalt blue, ivory black, and titanium white, and reinforce the darkest part of the goat at the back. Mix white, a little cadmium red, and yellow ochre, and add the lighter area at the top of the goat's back, the top of its head, and the top of the pig.

15 Use mixes of burnt sienna, alizarin crimson, ivory black, and titanium white for mid tones on the goat at the back. Place highlights with titanium white.

16 Mix alizarin crimson and titanium white for reflected colour on the goats' horns. Add the orange mix from Step 11 to the goats, and to the pig. Use burnt sienna, and yellow ochre for more colour on both goats.

▼ Farmyard goats

The use of a simple colour palette, based on the complementary colours of blue and orange, has created a harmonious final picture. Using the same colour mixes on the goats, the farmyard, and the shadows gives the painting unity.

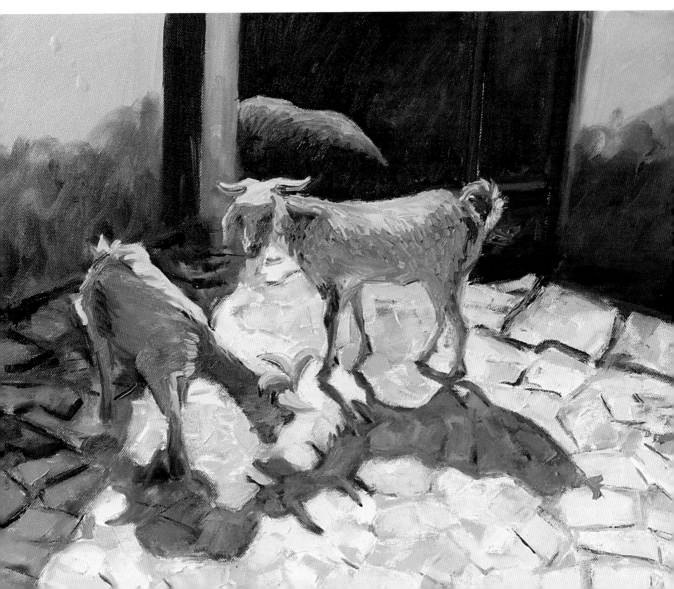

6 Anemones in a vase

This painting of a vase of flowers features a range of bright colours against a simple background. Its composition is unusual because the flowers are placed right at the top. While the round vase in the centre catches the eye first, the contrast of strong pink and blue flowers with the cool green background draws the eye up. The petals are simple blocks of colour rendered with a painting knife, with further colour overlaid by brush. Stippling in the centres and stamens creates the characteristics of anemone flowers.

EQUIPMENT
- Canvas
- Brushes: No. 2 round, No. 12 flat, No. 4, No. 6, and No. 8 filbert
- Painting knives: No. 21 and No. 24
- Turpentine or odourless thinner, impasto medium
- Lemon yellow, viridian green, ultramarine blue, cerulean blue, titanium white, magenta, permanent rose, violet, cobalt turquoise, ivory black, sap green, cadmium yellow, Prussian blue

TECHNIQUES
- Stippling
- Broken colour

Using the painting knife spreads the paint evenly.

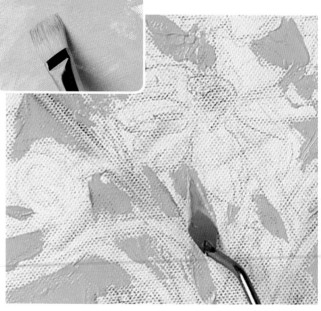

1 Sketch the outlines, focusing on the largest shapes. Mix lemon yellow, viridian green, and some impasto medium. Spread the paint with the No. 21 painting knife. Work from the edge, and drag the knife across the canvas.

2 Use the No. 24 painting knife to carefully paint in all the spaces between the flowers and inside the handle of the jug. Change to the No. 12 flat brush to paint in the larger areas at the sides of the picture.

BUILDING THE IMAGE

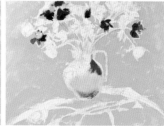
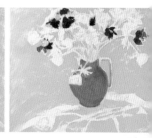

3 Paint some of the background mix on to the body of the vase where it reflects the green colour of the tabletop. Rub the paint in circular motions with a rag until it becomes translucent and the white of the canvas shines through.

4 Mix ultramarine blue and cerulean blue with a little titanium white and scumble on to the vase with a painting knife. Add titanium white and turpentine to the mix and paint the vase with the No. 8 filbert brush. Leave white canvas for overhanging flowers.

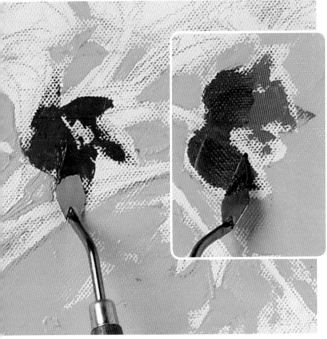

5 Mix magenta with titanium white to create a base colour for the pink flowers. Apply the paint to the flowers with the No. 24 painting knife. Add permanent rose to the mix and a little violet for variation. Leave some petals white for later colour.

6 Add more violet to the mix for a deeper purple shade. Apply this to create the base of the blue flowers and to the creases between the petals. Use the No. 24 painting knife to create areas of colour for petals rather than precise detail.

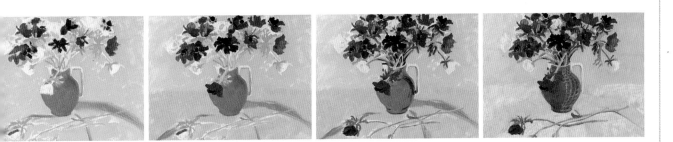

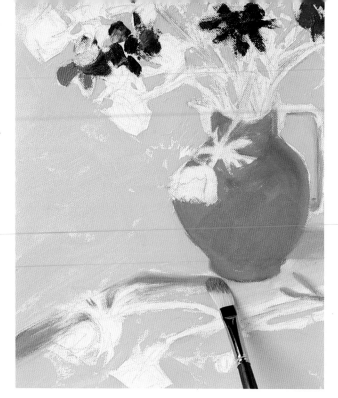

7 Mix some of the vase colour with the background mix and use this to paint in the folds of the cloth. Use the No. 6 filbert brush to do this. Paint some of the flower stems that are lying on the table with this mix too.

8 Mix lemon yellow, viridian green, cobalt turquoise, and titanium white. Using the No. 2 round brush, paint this soft green mix on the leafy fronds around the blooms and on some of the flower stems.

9 Add some titanium white to the pinker flower mix from step 5 and use the No. 4 filbert brush to paint in the pink flowers. Add more titanium white to the mix for variation where the light shines through the petals. Stipple ivory black stamens into the centres of the flowers.

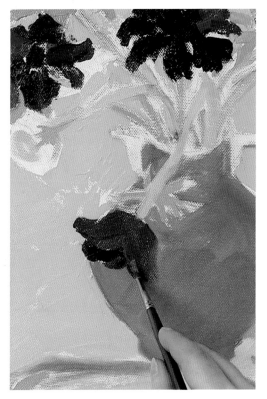

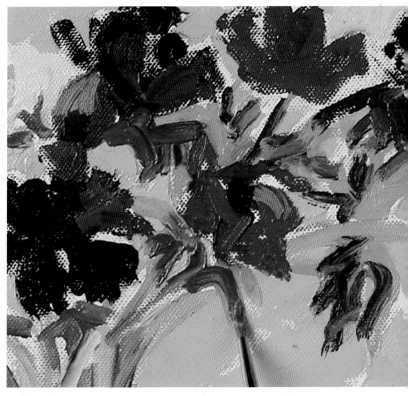

10 Mix violet and cerulean blue to make a purple, and paint individual flower petals. Paint over some petals using the pink, violet, and blue mixes.

11 Mix viridian green, sap green, and some titanium white, and draw the paint up the stems of the flowers. Use the No. 2 round brush to paint in the shadowed stems and fronds with a mix of cadmium yellow, viridian green, and cobalt turquoise.

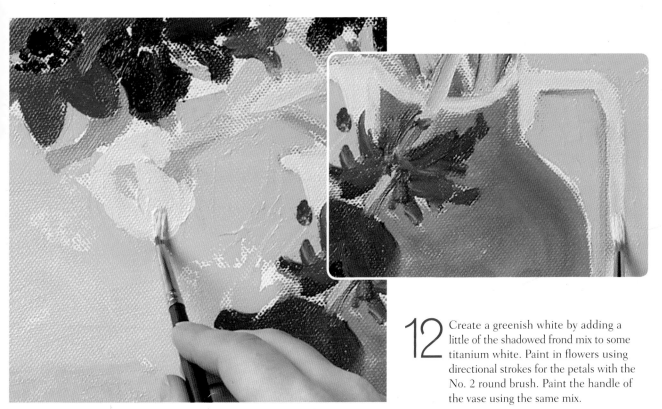

12 Create a greenish white by adding a little of the shadowed frond mix to some titanium white. Paint in flowers using directional strokes for the petals with the No. 2 round brush. Paint the handle of the vase using the same mix.

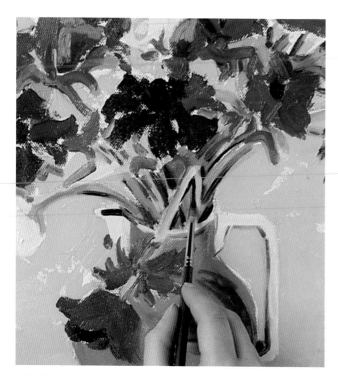

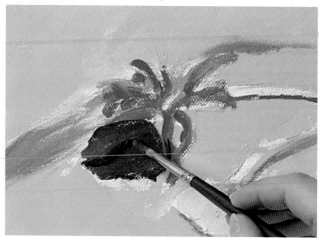

14 Define the petal edges of the closed flowers on the table with a mix of cerulean blue, titanium white, and magenta. Go back over all the flowers with the No. 2 round brush refining the shapes, and varying the mark making.

"Use broken colour to add vibrancy to the paint surface."

13 Return to the shadowed frond mix and add some ivory black. Use this to mark in more shadows between the stems of the flowers. Paint shadow under the handle of the vase and at the base of the vase with this mix too.

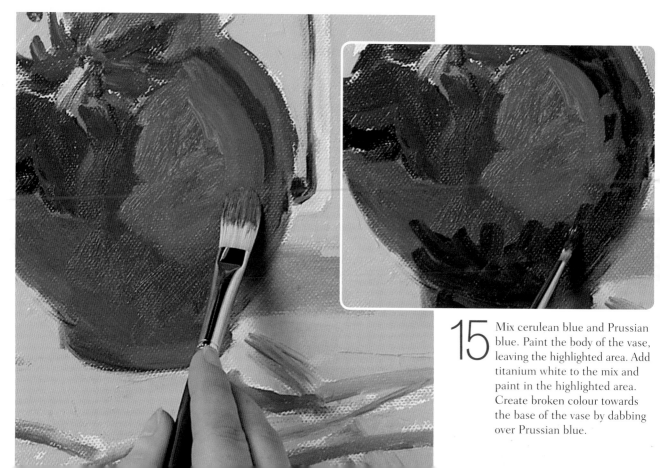

15 Mix cerulean blue and Prussian blue. Paint the body of the vase, leaving the highlighted area. Add titanium white to the mix and paint in the highlighted area. Create broken colour towards the base of the vase by dabbing over Prussian blue.

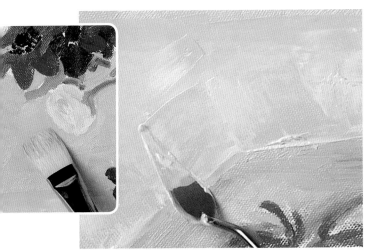

16 Dab more colour over the background with the mix from step 1. Add titanium white to the mix and apply it to the tabletop with the No. 21 painting knife. Partly paint in the pattern of lines on the vase.

▼ Anemones in a vase

Painting the anemone petals as simple shapes has enhanced the effect of vibrant colour against the cool green background and table. The strong blue of the vase intensifies the blue, magenta, and violet of the flowers.

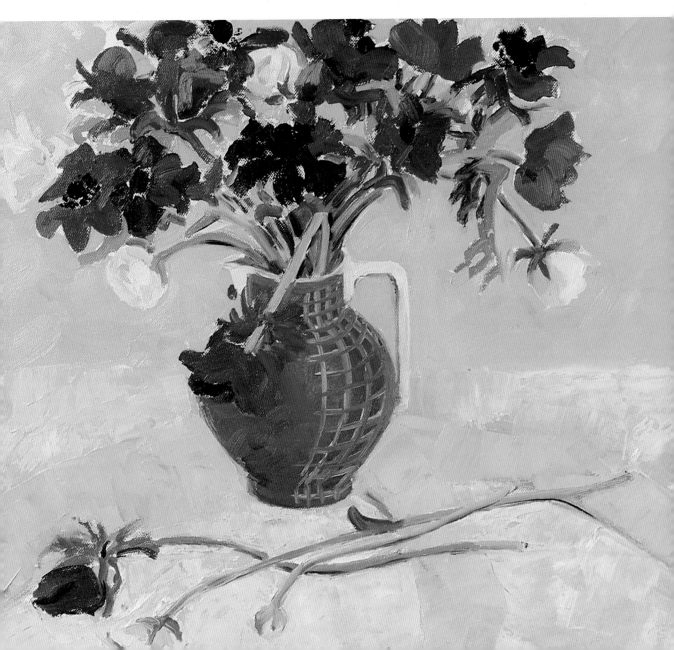

Perspective

"Use colour and line to
create a sense of depth
in your paintings."

Understanding perspective

Perspective is a means of making a two-dimensional surface appear three-dimensional, distinguishing foreground objects from those in the distance and thus creating depth. It also establishes the relative position and size of figures and objects in the painting. The application of the rules of perspective is not necessarily a very complicated matter – making the perspective believable will suffice. Two ways to give the illusion of depth in a painting are linear perspective and atmospheric perspective.

ATMOSPHERIC OR COLOUR PERSPECTIVE

Because of atmospheric haze, a distant landscape appears progressively bluer and paler to us than the foreground. As colours appear warm or cool, and advance or recede respectively, you can use them to reflect this atmospheric phenomenon in your painting. The line through the colour wheel shown here divides the warm colours veering to red from the cool colours, which tend towards blue. Redder colours advance, while bluer ones recede.

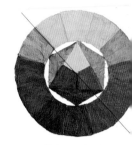

Colour wheel

The warmth or coolness of an individual colour depends upon the amount of blue or red in it. While red is intrinsically a warm colour, for example, there are warm reds and cool reds.

Warm colours

Cool colours

The hills are blue and lack detail, giving the impression of great distance.

The warm red of the flowering bush draws it closer to the eye.

This landscape shows how warm colours advance to the foreground while cool ones recede. The size of the buildings places them in the middle distance.

LINEAR PERSPECTIVE

All parallel lines in a scene converge to a point known as the vanishing point, which may be inside or outside the picture plane. Lines from subjects placed higher than the eyeline descend to the vanishing point, while those lower ascend.

Parallel lines running in a different direction have a different vanishing point. Figures and objects become smaller the further back they are in the picture plane, because they are also governed by the rules of perspective.

One-point perspective

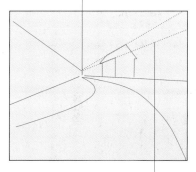

In this painting, looking straight down the street, the parallel lines of the roofs, railings, and road converge to a single vanishing point.

Because the roof line is higher than the artist's eye level, it descends to meet the road, which rises towards it.

Two-point perspective

Here the building stands at an angle, with two sides visible. The parallel lines of each side converge outside the picture frame.

Taken to their conclusion, the lines from the front and side of the building would meet at two different vanishing points.

Atmospheric and linear perspective can be used either singly or together to bring a persuasively three-dimensional quality to a work.

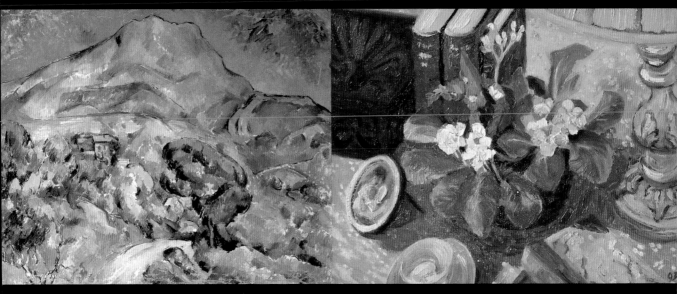

▲ Mont Sainte-Victoire

The perspective of this mountain scene is established by making the reds and greens more vibrant in the foreground and middle ground, with cool blues fading into the distance. *Paul Cézanne*

▲ Primulas

Even this close-up of objects on a table top obeys the rules of linear perspective. The parallel sides of the books and the wooden box will meet somewhere above the painting's edge. *Aggy Boshoff*

Labranda, Turkey ▶

The strong tonal contrast of dark tree trunks against a light background emphasizes the depth in this painting. Warm colours and defined shapes make the foreground advance, while the background is an indistinct haze of cool blues. *Brian Hanson*

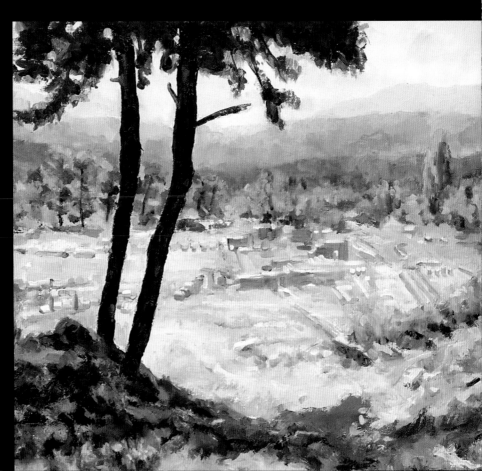

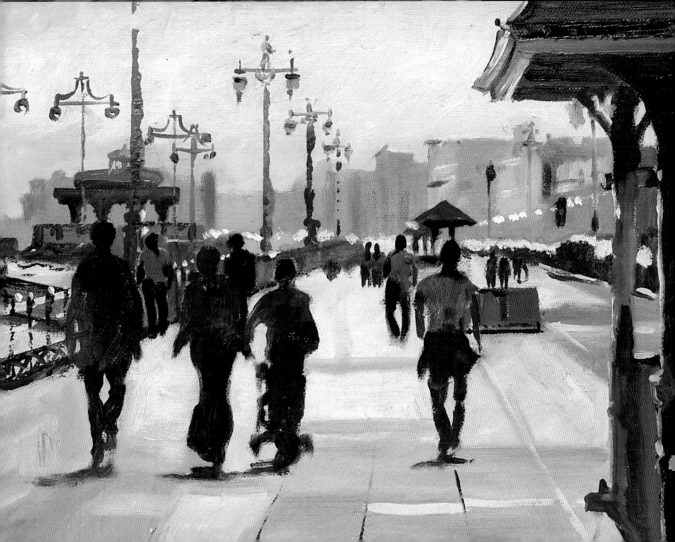

◄ Le Pont de Trinquetaille

The fan-shaped parallel lines of the foreground steps give an exaggerated perspective to make this bridge, which was modern for its time, seem more impressive. *Vincent van Gogh*

▼ Evening stroll on Brighton promenade

The one-point perspective and the diminishing height of the figures silhouetted against the sun give a strongly three-dimensional effect, reinforced by the paler colours of the background. *Mark Topham*

7 Boats in the harbour

A sense of depth is created in this sunny harbour scene as the size of the boats and the paving slabs in the foreground are painted larger than the background buildings. The lines of the boats and pavement lead the eye into a jumble of warm colours and shapes, which you soon recognize to be buildings and their reflections. Painting the reflections slightly darker helps to differentiate them from the buildings, which are in full sunlight. To create their watery quality, the reflections are painted thick with added impasto medium, then dragged through with a comb.

EQUIPMENT
- Canvas
- Brushes: No. 2 round, No. 8 and No. 12 flat, No. 4 and No. 6 filbert, No. 6 fan
- Painting knives: No. 24
- Turpentine or odourless thinner, linseed oil, impasto medium
- Lemon yellow, cobalt turquoise, cerulean blue, yellow ochre, titanium white, cadmium red, burnt sienna, ultramarine blue, ivory black, raw sienna, Prussian blue, cadmium yellow, alizarin crimson, viridian green

TECHNIQUES
- Drybrush
- Combing

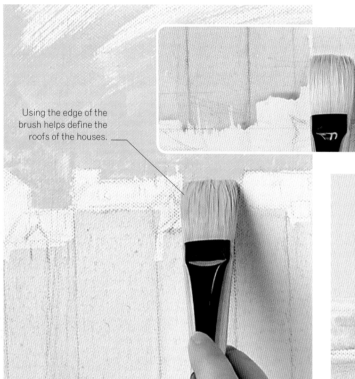

Using the edge of the brush helps define the roofs of the houses.

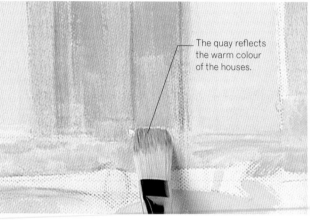

The quay reflects the warm colour of the houses.

1 Dip the No. 12 flat brush in turpentine before using it to mix up a glaze of lemon yellow for the lightest areas of the houses and the river. Paint the sky, boats, and pavement with a mix of cobalt turquoise, cerulean blue, and turpentine.

2 Mix yellow ochre and titanium white with some turpentine. Use the No. 8 flat brush to paint in the sunlit areas of the houses and quay. Add some cadmium red and lemon yellow to the mix for the warmest areas of the houses and reflections.

BUILDING THE IMAGE

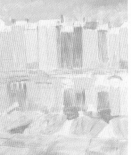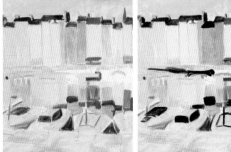

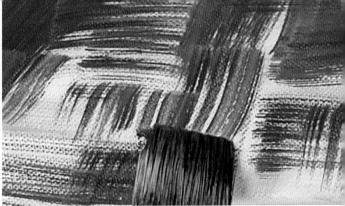

3 Mix burnt sienna, ultramarine blue, and a touch of titanium white. Use the No. 4 filbert brush to paint in the roofs of the houses, knitting them together rather than drawing them individually, and to sketch in foreground detail. Add a little ivory black to the mix for the boat shapes and shadows.

4 Mix burnt sienna, raw sienna, ultramarine blue, and titanium white. Paint the darker reflections with the No. 6 filbert brush, using dry brushwork in some areas. Mix Prussian blue with the sky mix. Darken the pavement with light strokes using the No. 8 flat brush.

6 Lighten the pavement mix with titanium white, cobalt turquoise, and cadmium yellow. Mix in some turpentine and linseed oil, and use the No. 12 flat brush to drag the colour down into the sky. Add more titanium white to the mix for details on the boats and the paving stones.

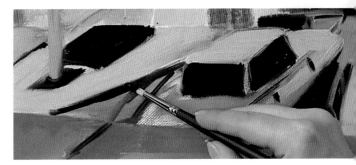

5 Mix cadmium yellow and cadmium red, and thicken with some impasto medium. Use the No. 8 flat brush to work this orange mix into the houses and the reflections. Comb through the paint to make vertical scratches.

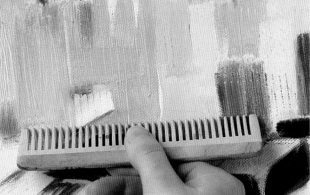

7 Mix ivory black and ultramarine blue. Use the No. 2 round brush to paint in the darkest details of the gaps in the paving stones and the boat edges. Mix cobalt turquoise and titanium white for further detail on the boats and masts.

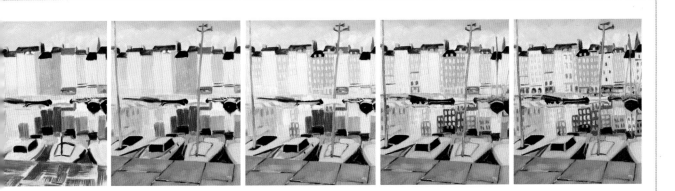

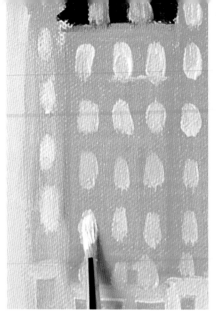

8 Mix titanium white with a little lemon yellow and use the No. 6 fan brush to drag some highlights over the fronts of the houses.

9 Mix pure titanium white with some turpentine and linseed oil. Paint in the windows and white boats using the mix thickly on your brush.

10 Mix cadmium red and a touch of cadmium yellow with turpentine. Add detail to the far boats and masts. Paint the mast reflections.

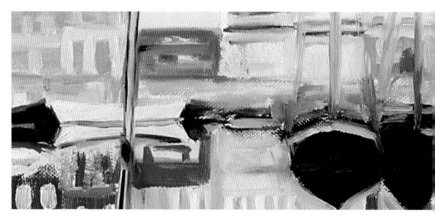

11 Mix alizarin crimson and ultramarine blue for parts of the water and the dark windows. Mix lemon yellow, viridian green, and turpentine to paint the doorways and some shop fronts. Outline the foreground masts with a mix of burnt sienna and ivory black.

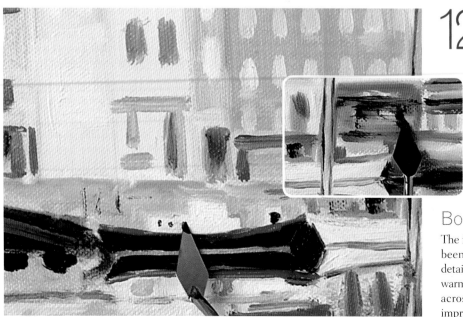

12 Use pure ivory black on the edge of a painting knife to scratch in some darker details at the street level and to dot in the windows of the boat. Use the painting knife to make distinct marks.

Boats in the harbour ▶

The foreground area of this painting has been kept simple with relatively little detail. This emphasizes the confusion of warm, detailed buildings and reflections across the water, which creates the impression of a busy harbour.

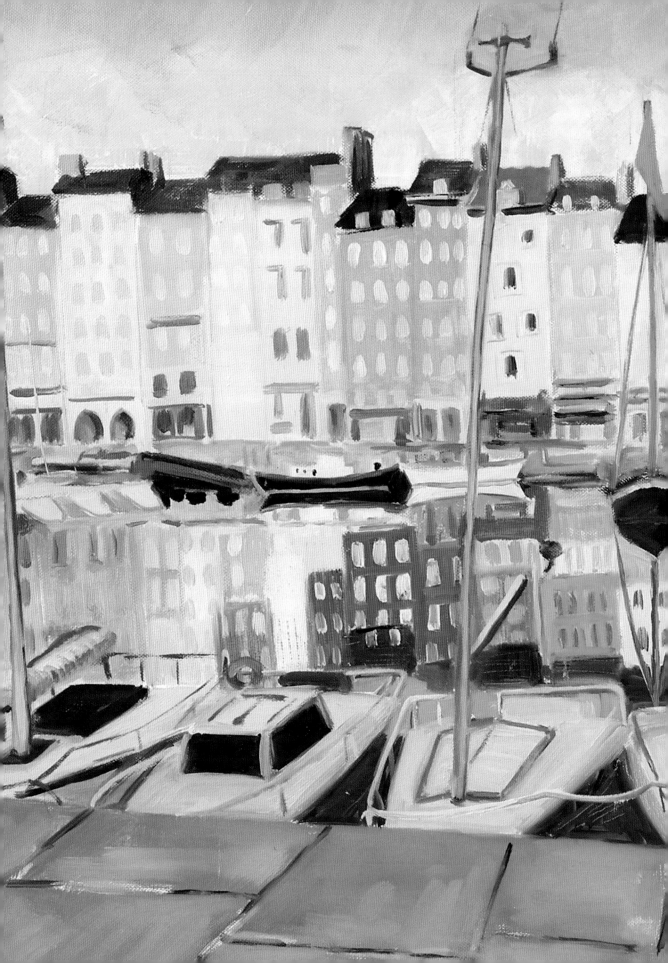

8 Spanish landscape

In this painting of a sun-drenched landscape, perspective has been captured through careful use of colour and detail. The foreground is painted with the brightest colours to bring the area forward, the middle distance is painted with lighter colours, and the mountains are painted with cool blues as they recede into the distance. Shapes in the middle distance are smaller and more sketchy than those in the foreground, while the mountains show no details at all. Hatching and dabbing are used to add interest to the fields and detail to the olive groves.

EQUIPMENT

- Canvas
- Brushes: No. 2 round, No. 12 flat, No. 8 filbert
- Turpentine or odourless thinner, linseed oil
- Cobalt turquoise, titanium white, cadmium yellow, cadmium red, viridian green, sap green, ultramarine blue, cerulean blue, alizarin crimson, burnt sienna, ivory black, lemon yellow, Prussian blue

TECHNIQUES

- Hatching
- Dabbing

The cool blue in the mountains helps them to recede into the distance.

Trees and foliage are quickly created with a dryish brush.

1 Mix cobalt turquoise and titanium white with turpentine and linseed oil. Paint the sky, and parts of the mountains, and scumble the mix over cooler field areas. Mix cadmium yellow and titanium white with turpentine and linseed oil to establish field colours.

2 Add cadmium red to the field colour for the olive groves, and more for the areas of exposed earth. Add viridian green, sap green, cadmium yellow, titanium white, and turpentine to the sky mix for the base of the mountains. Add more cadmium yellow for the foreground fields and greenery.

BUILDING THE IMAGE

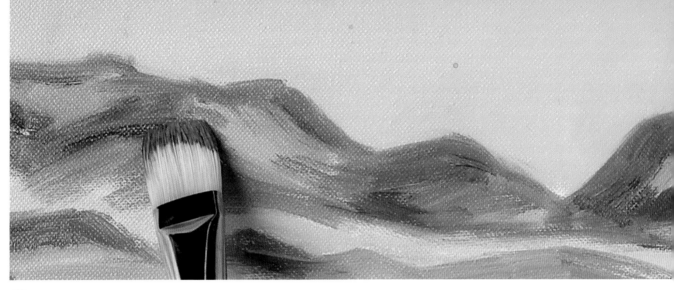

3 Mix ultramarine blue, cerulean blue, alizarin crimson, and burnt sienna, with turpentine and linseed oil. Use the No. 12 flat brush to paint the mountains. Accentuate the darker areas by adding more ultramarine blue to the mix. Add titanium white for nearer areas.

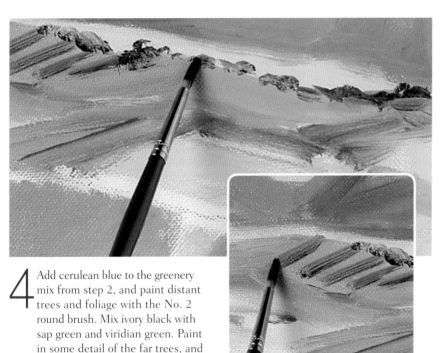

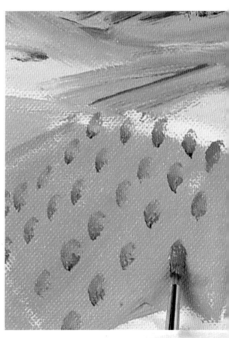

4 Add cerulean blue to the greenery mix from step 2, and paint distant trees and foliage with the No. 2 round brush. Mix ivory black with sap green and viridian green. Paint in some detail of the far trees, and hatch lines over the fields.

5 Dab in the olive trees with a mix of titanium white, sap green, viridian green, and cerulean blue. Add lemon yellow to the greenery mix to paint the remaining fields towards the right foreground and to add undulations to the darker fields.

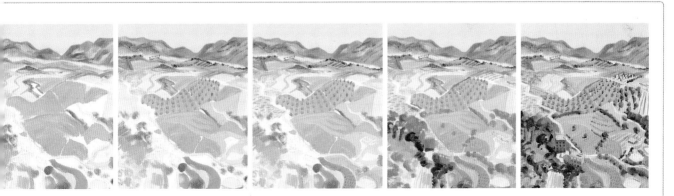

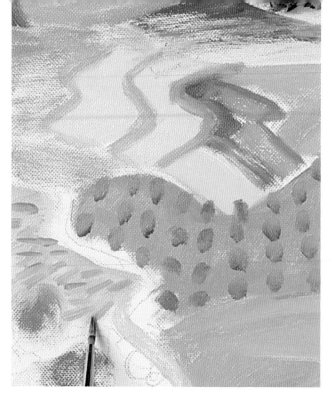

6 Mix sap green and cadmium yellow with turpentine. Hatch the field on the far left with irregular lines. Vary the hatching in colour and shape for fields further in the background and to the right to give different effects.

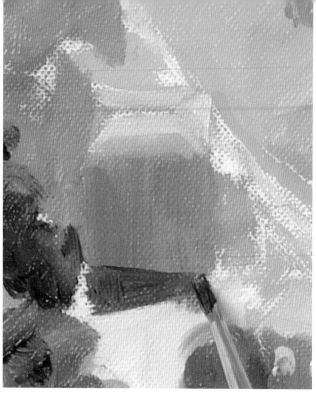

7 Paint the fronts of the houses with the mountain mix from step 3. Add titanium white to the olive tree mix from step 5, and paint in the roofs of the houses. Add alizarin crimson, cerulean blue, and more turpentine for the shadows of the houses.

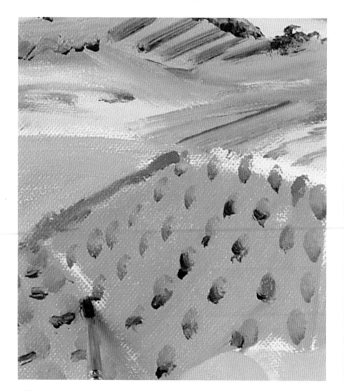

8 Add a little more ivory black to the greenery mix to mark in the shadowed areas underneath the olive trees. Paint with the side of the brush, working in a diagonal direction. Use the direction of your shadows to indicate the contours of the land.

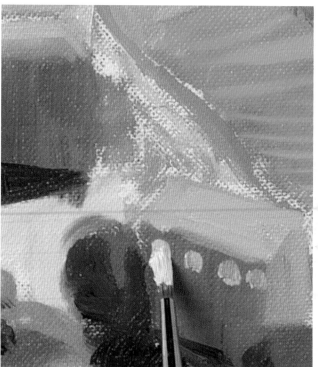

9 Mix titanium white with a little cerulean blue to highlight the roofs of the houses and to paint the lighter windows. Mix ivory black, viridian green, and alizarin crimson to paint the darker windows, the rooflines and other details on the houses.

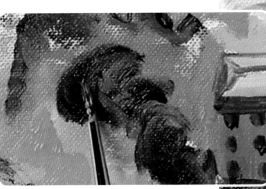

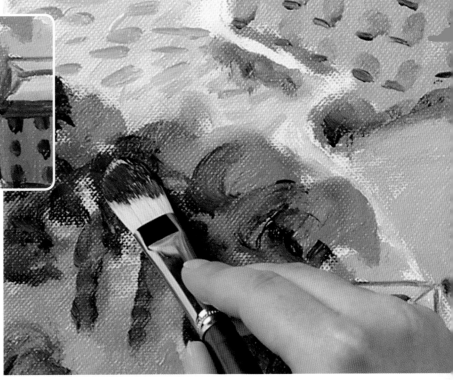

10 Mix viridian green, cadmium yellow, and titanium white for the foreground trees, linking the areas of green together with the No. 8 filbert brush. Add more cadmium yellow for variation. Use the darker house detail mix from step 9 to put the shadows in the trees, using curved strokes.

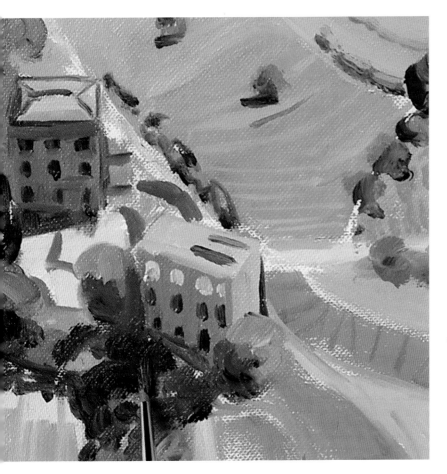

"Keep details sketchy so they blend in with the whole landscape."

11 Change to the No. 2 round brush to fill in some of the green borders around the fields, and the remaining white areas towards the front of the painting, with the yellower green mix from step 10. Paint stronger greens in the foreground using the shadow mix from step 7 with a little viridian green.

12 Mix ivory black, cerulean blue, cadmium yellow, and turpentine to make an olive green. Paint in the olive trees on the right side of the painting with the No. 2 round brush, creating variation in size and shape.

13 Mix Prussian blue, titanium white, and alizarin crimson, and paint contrasting hatches on the yellow fields. Use the mountain mix from step 3 to accentuate the shadows under the houses and dab under the trees on the left.

14 Mix alizarin crimson, cadmium red, and titanium white to make a cool pink colour. Paint the roads with smooth strokes, varying the pressure.

LIGHT AND SHADE

Sunlight lightens the colour of objects but creates strong shadows. The resulting large tonal range can add interest to a landscape.

Spanish landscape ▶

This landscape is a patchwork of harmonious colours that get smaller and less detailed towards the distance. A variety of abstract marks keeps the eye engaged on its journey through the landscape.

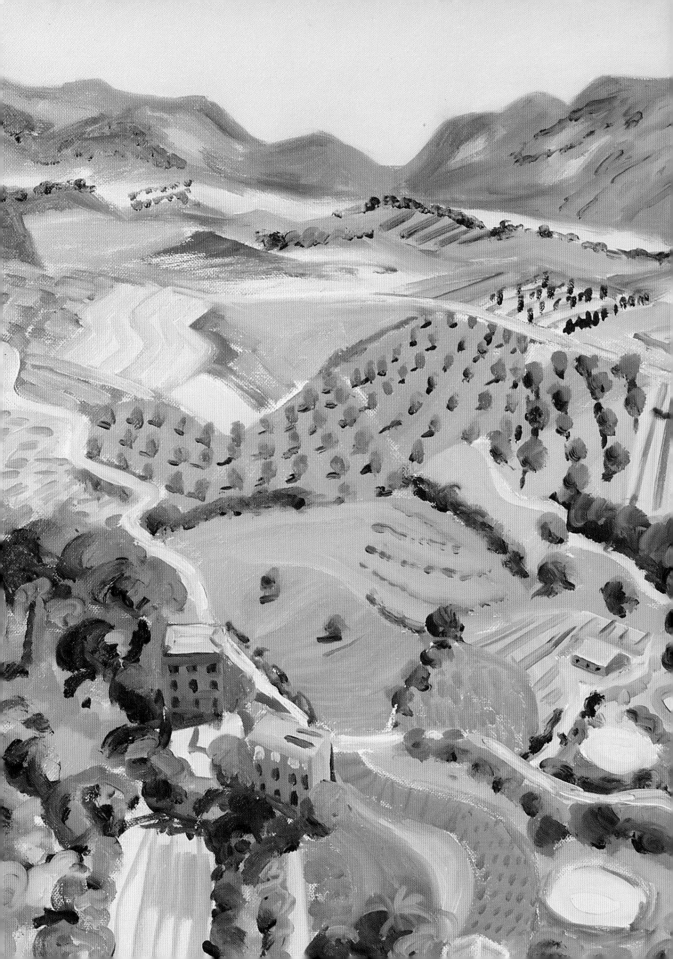

9 Café scene

The essential element for this scene of an outdoor café in a city square is the use of one-point perspective. The painting is given dynamism by lines that radiate from a vanishing point that is positioned in the top left of the picture. A second vanishing point, created by the parallel lines of the square and the buildings' façades, is set far outside the frame to the right. The use of masking tape helps to establish these points before the painting begins. Adding a variety of figures brings life and scale to an otherwise empty scene.

EQUIPMENT
- Oil painting paper
- Brushes: No. 2 round, No. 8 flat, No. 4 filbert, No. 6 fan
- Painting knives: No. 20
- Turpentine or odourless thinner, painting medium, masking tape
- Alizarin crimson, cadmium red, Prussian blue, titanium white, cobalt turquoise, burnt umber, ivory black, cadmium yellow, lemon yellow, ultramarine blue, cerulean blue

TECHNIQUES
- Masking tape
- Adding figures

THE VANISHING POINT

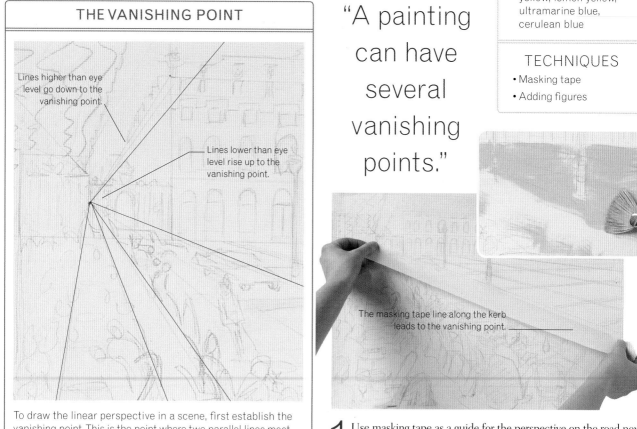

Lines higher than eye level go down to the vanishing point.

Lines lower than eye level rise up to the vanishing point.

The masking tape line along the kerb leads to the vanishing point.

"A painting can have several vanishing points."

To draw the linear perspective in a scene, first establish the vanishing point. This is the point where two parallel lines meet and cross on the horizon, which is at your eye level. You may find it helpful to use a ruler when drawing the perspective in your pre-painting sketch.

1 Use masking tape as a guide for the perspective on the road next to the kerb. Paint the square and part of the road with a mix of alizarin crimson, cadmium red, Prussian blue, a lot of titanium white, and turpentine. Use the No. 6 fan brush and horizontal strokes, painting over the top edge of the tape in places.

BUILDING THE IMAGE

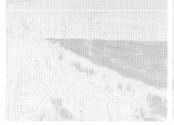

2 Mix a sky blue from Prussian blue, cobalt turquoise, titanium white, and turpentine. Paint the sky with the No. 8 flat brush, leaving areas white for clouds. Make the roofline more precise as you paint the sky. Use this mix in places in the café area.

3 Remove the masking tape. Paint the rest of the road, which was covered with masking tape, with the lilac mix from step 1, leaving the kerb. Paint over areas of the road with the sky mix from step 2 to differentiate it from the paved square and to add texture.

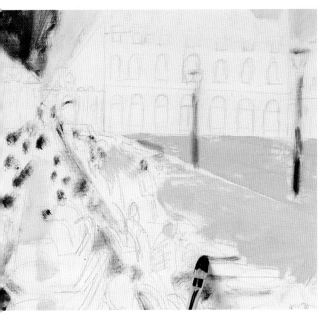

4 Mix a warm black from burnt umber, cadmium red, ivory black, and turpentine to paint the café in the shadow and its awning. Dab in the heads of people with this mix using the No. 4 filbert brush. Scumble in the lampposts and the shadows among the tables and chairs.

5 Mix cadmium red, cadmium yellow, and turpentine. Use this orange mix to add colour in the café, and to paint the chair backs. Mix cadmium yellow, lemon yellow, titanium white, and turpentine for sunlight on the terrace. Paint the buildings with this mix too, leaving the windows white.

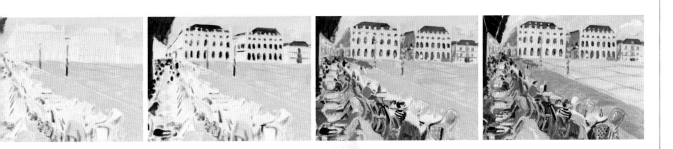

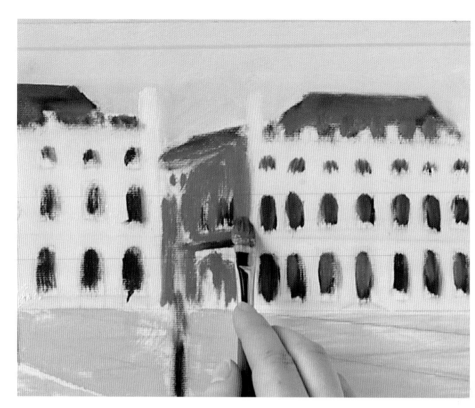

6 Add ultramarine blue to the warm black mix from step 4 to make a darker blue for the windows and rooftops. Add some of the sky mix from step 2 to lighten and vary the roofs and windows, and for the shaded sides of the buildings.

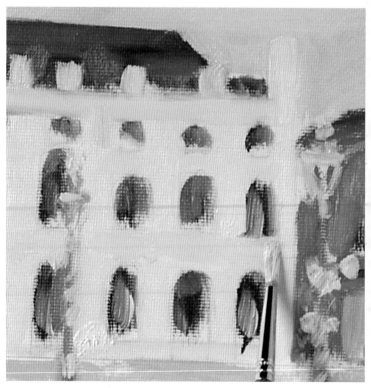

7 Use the orange mix from step 5 to paint the rattan chairs in the foreground, using the No. 2 round brush. Use the mix for accent colour, for the shirt, and beer in the glass, elsewhere in the foreground, and for detail on the lampposts.

8 Use cadmium red on some figures sitting at the café tables, and on items on the tables. Mix a light yellow from titanium white, lemon yellow, and turpentine, to paint the tabletops, to enliven the façades of the buildings, and to render the lighter decoration on the lampposts.

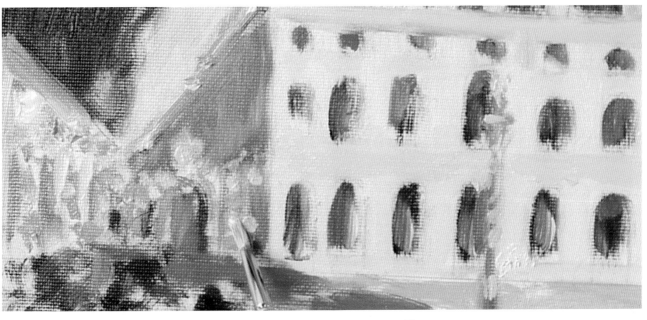

9 Mix lemon yellow, cadmium yellow, titanium white, and turpentine. Use this mix for detail on the gates and on some figures at the front of the café. Mix ultramarine blue, alizarin crimson, and turpentine for one of the figure's shirts.

FIGURES

Figures in a painting must also be in perspective. Remember, the heads of people in the distance should be painted relatively smaller than those of people in the foreground.

10 Mix ultramarine blue, cerulean blue, and turpentine for shadows under chairs. Use the orange mix from step 5 to dot in ovals for receding faces. Add titanium white to the mix for faces in the foreground. Mix a very light pink of titanium white and a little cadmium red for skin in sunlight.

11 Mix titanium white with turpentine and painting medium to paint the clouds. Mix in cobalt turquoise, and paint the sky and tabletops. Use the No. 20 painting knife to scratch in titanium white highlights to the area in front of the café to make the distant people look less distinct.

12 Lighten the awning and add the metal struts by drawing in lines of cadmium yellow mixed with painting medium. Mix titanium white with a little Prussian blue and painting medium and apply to the clouds with a painting knife to tone them down.

13 Lighten the square with a mix of titanium white and a little cerulean blue. Mix alizarin crimson, Prussian blue, titanium white, and painting medium, to darken the road, varying the colour as you paint. Use this mix to redefine the lines in the square.

14 Mix a dark green from ivory black and cadmium yellow to paint the bottle, details on the chairs, and areas of shadow among the figures. Paint the hair on the heads of some of the figures with the orange mix from step 5 and ivory black.

▼ Café scene

In this painting a real sense of depth has been created by its consistent use of perspective. The road, buildings, and café all converge at one vanishing point and the people at the café who are further away are depicted with smaller dabs of colour.

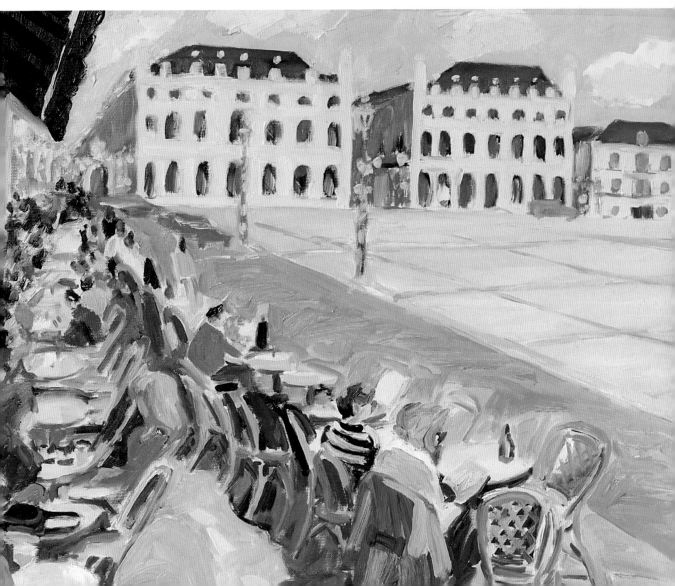

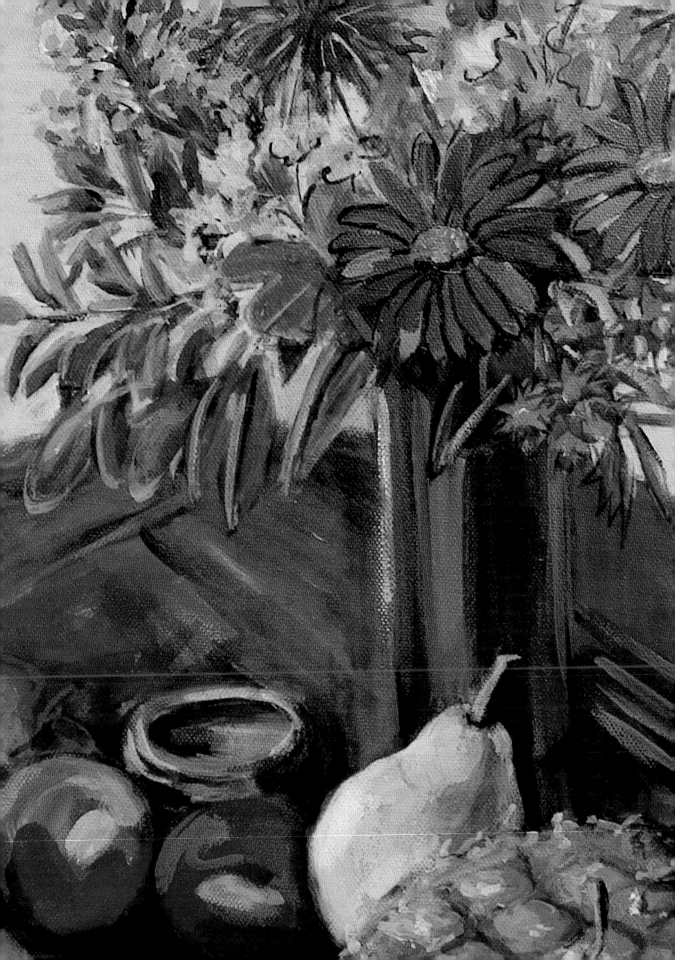

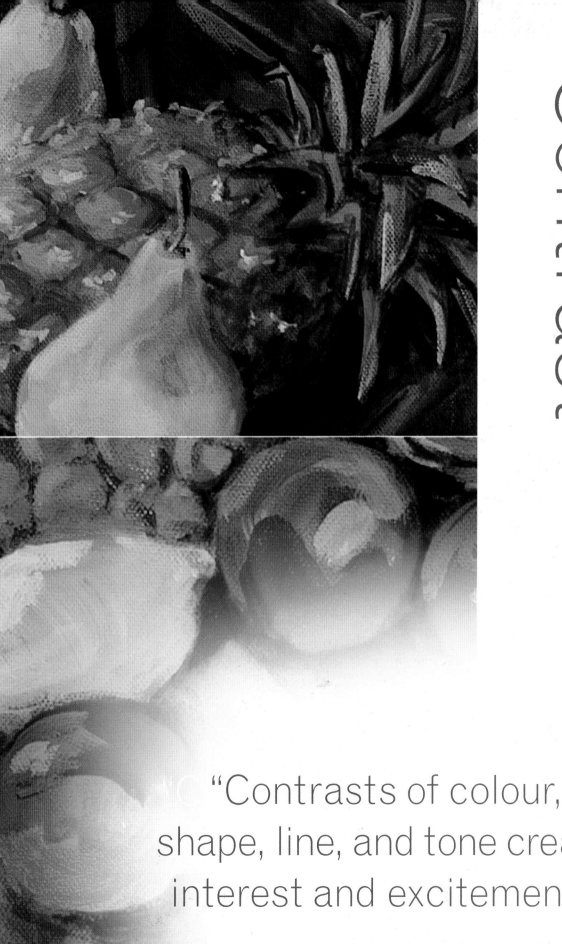

"Contrasts of colour,
shape, line, and tone create
interest and excitement."

Creating contrast

Just as a piece of music benefits from contrasting sounds, so a painting is made exciting by visual contrasts. The most important of these is in the use of colours, with bright ones set against muted, warm ones contrasted with cool. Remember also to look for contrast in large and small shapes, lines that are short or long, thick or thin, edges that are soft or hard, and textures that are smooth or rough. Set verticals against horizontals, light tones against dark, and lines against colour fields.

COLOUR

Colour contrasts can be used to good effect in your paintings. As well as the vibrant and harmonious contrast of complementary colours (*see. p.56*) try contrasting bright and muted, and cool and warm colours. Place a little bright colour between more saturated or muted colours, which reflect less light, for a strong statement. Create a balancing contrast with warm and cool colours: too many cool colours can make your painting feel unpleasantly cold in atmosphere, so add contrasting warmer colours.

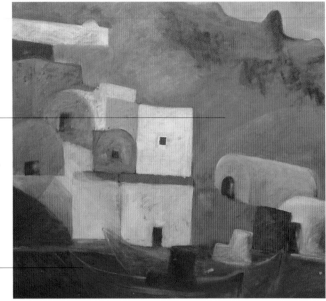

The pinks and yellows of the rocky hillside create a warm contrast.

The water and foreground rocks are glazed with cool blues.

EDGE

Vary the edges between two colours to create both hard- and soft-edged shapes. The resulting contrasts of definition will add interest to your painting. Do not be afraid to leave some areas of your painting less explicit – there is no need to spell out everything all of the time. The eye is sophisticated and corrects and concludes for itself.

As the main focus of the painting, the hedge, urn, and plant have been given hard edges.

The stone surface in the lower half of the painting consists entirely of soft edges.

LINE

Pay as much attention to the lines in your painting as you do to the colour fields. Emphasizing the outlines of certain objects will make them stand out as important elements of the design. Consider the direction of the lines you use to improve the dynamic of your painting. Verticals and horizontals are elements of balance, whereas diagonals are unbalancing and surprising.

The vertical stems of the plants contrast with the diagonals and provide a natural balance.

The strong, repeated, diagonal lines of the tablecloth give the painting impact.

TONE

Use the contrast of light and dark tones to give focus to your painting. The darker tones immediately lead the eye to the lighter areas in your work. Placing your lightest mark next to your darkest establishes the focal point of your painting. However, while the extreme contrast of light and dark tones is very useful to employ, make sure that you work up the mid tones too, so that your painting does not seem harsh and unresolved.

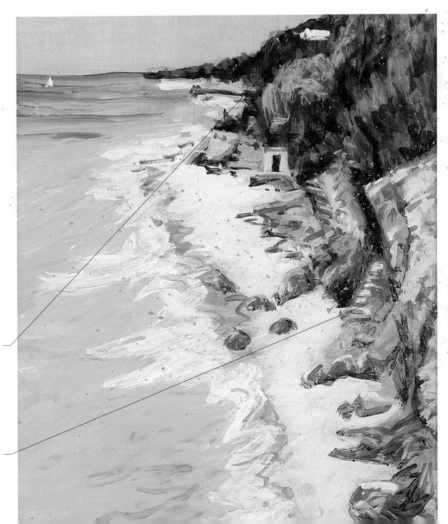

The darker tones of the greenery throw the emphasis onto the delicious turquoise wedge of sea.

The mid tones have been developed to add to this tranquil scene.

Flowers and fruit ▶

Harmonious contrast is found here in the complementary colours of red against green and yellow against violet. The tonal contrasts of the mid colours in the vase and fruit unify the painting. *Aggy Boshoff*

▼ Winter fishing boats, Folkestone harbour

The pink and brown tones of the jetty and pier are a warm contrast to the cool light blue colours of the harbour, sea, and sky. *Christopher Bone*

◀ Cypress Point

There are strong tonal contrasts here between the white waves and pale sand and the dark tones of shadowed foliage and rocks. The defined brushwork of the foreground grass stands out against the soft shadow area behind it. *Aggy Boshoff*

▼ Portrait of a girl in Spanish dress

The black and white of the dress are a bold tonal contrast against the light skin and blond hair of the model. Her face is in shadow where it is set against the paler area of background. *Aggy Boshoff*

▲ Woman with a candle

The bold contrast between light and dark known as *chiaroscuro* is the most notable feature here, but there is also harmonious contrast of green and red. *Godfried Schalken*

◀ California sunset

Dark trees stand out strongly against the light sky. The foreground trees have hard edges, and the distant forest is a soft-edged blur. Violet and yellow are juxtaposed in the sky to add colour contrast. *Albert Bierstadt*

10 Still life

The objects in a still life picture are carefully selected and arranged. For this painting the lemon and bottle have been moved back and forth to harmonize best with the plate, and the crab, and prawns. The shapes of the lemon, spots on the cloth, and the bottom of the bottle mimic those of the plate, crab, and prawns, and contrast with the diagonal lines on the cloth and the verticals of the bottle. These shapes, and the tones, are set with thin blue before strong colours, such as cadmium scarlet, and thicker paint are used. Final refinements to colour and texture are scratched in.

EQUIPMENT

- Canvas
- Brushes: No. 2 round, No. 8 flat, No. 4 and No. 6 filbert
- Painting knives: No. 21 and No. 24
- Turpentine or odourless thinner, impasto medium
- Cobalt blue, cerulean blue, titanium white, cobalt turquoise, lemon yellow, cadmium yellow, alizarin crimson, burnt sienna, yellow ochre, cadmium red, ivory black, ultramarine blue, Prussian blue, raw sienna, viridian green

TECHNIQUES

- Painting knife
- Scratching

SETTING UP A STILL LIFE

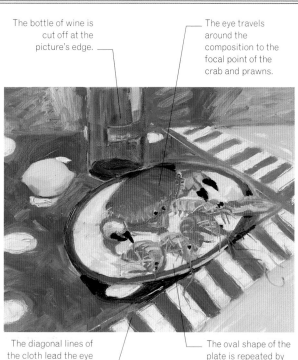

The bottle of wine is cut off at the picture's edge.

The eye travels around the composition to the focal point of the crab and prawns.

The diagonal lines of the cloth lead the eye out, then back into the picture.

The oval shape of the plate is repeated by the lemon and spots of the cloth.

Take time to set up a still life. Think of the objects in terms of simple shapes such as circles, rectangles, and triangles. This will make it clear how they relate in space to each other. A good still life consists of strong shapes.

Paint with turpentine establishes all the basic shapes.

1 Sketch the composition in pencil. Paint the tablecloth with cobalt blue. Mix cerulean blue, titanium white, and cobalt turquoise, and paint the area behind the table, the shape of the bottle, and the shadows on the lemon, under the plate, and under the crab.

BUILDING THE IMAGE

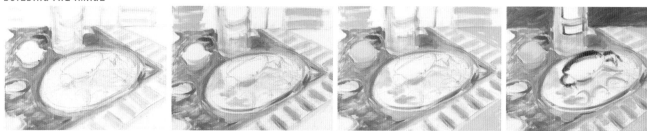

2 Mix lemon yellow, titanium white, and turpentine to paint the lemon. Use thin cadmium yellow with a No. 4 filbert brush to paint the lightest areas of the prawns and the white areas of the plate's shadow. Paint the tabletop cadmium yellow, using the No. 8 flat brush. Add cadmium yellow into the darkest areas of the lemon.

"Directional strokes can help give an object shape."

3 Add shape to the bottle with light strokes using the first lemon mix from step 2. Outline the labels on the bottle with a mix of cobalt blue and alizarin crimson. Add ultramarine blue to this mix to add colour to the background. Mix cobalt blue with a little titanium white to strengthen the cloth.

Simple semi-circular brushstrokes create the prawns.

4 Mix a dark orange from burnt sienna and yellow ochre. Paint the far edge of the crab with this mix using the No. 6 filbert brush. Mix cadmium yellow, lemon yellow, and cadmium red to make a bright orange for the rest of the crab and the prawns.

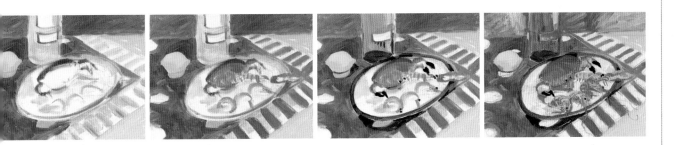

5 Strengthen the stripes on the tablecloth with cobalt blue. Add more detail to the crab and prawns with the bright orange mix, then paint some parts with strong, pure cadmium red.

6 Mix ivory black and ultramarine blue for the crab's claws. Mix lemon yellow, cadmium yellow, titanium white, and cobalt blue for the bottle. Add Prussian blue and cadmium yellow to paint the bottle's base.

7 Paint the rim of the plate with a mix of cobalt blue and titanium white. Paint the eyes of the crab and the prawns with ivory black. Add shadows to the bottle and the edge of the plate with ivory black, painting wet-in-wet.

BRUSHSTROKES

For expressive, and determined, detailed brushstrokes, load the brush with paint and push it down firmly so that a decisive dab of paint is placed.

8 Add more cadmium red to the bright orange mix and use this to paint the stripes on the prawns. Mix titanium white with a little cadmium red to paint the lightest pink flesh on the prawns, using the No. 2 round brush. Return to the brighter colour to lightly paint feelers on the prawns.

9 Mix a warm lilac using alizarin crimson, cobalt blue, Prussian blue, and titanium white. Use the No. 4 filbert brush to paint shadows under the crab and prawns, on the top of the crab, and in the bottle.

10 Mix cadmium red and titanium white for spots on the tablecloth. Use this mix and the No. 24 painting knife to paint the white of the plate, varying with a little lemon yellow and titanium white.

11 Paint the stripes on the tablecloth with a mix of titanium white and cobalt blue. Lighten them by overpainting with a titanium white and lemon yellow mix. Use this mix on the spots on the tablecloth too. Add more white to the mix to paint the plate. Keep the paint clean by wiping off any colour that is lifted from the painting.

12 Add mixes of cobalt turquoise or Prussian blue, and titanium white, to the background. Mix raw sienna and viridian green with impasto medium, and paint the bottle with vertical strokes using a No. 21 painting knife.

13 Paint the rim of the plate with pure cadmium yellow in areas where the light hits the gilding. Use a mix of Prussian blue and titanium white to liven up the edge of the plate. Add cadmium red to the bright orange mix. Use this mix to refine the prawns' feelers, and to strengthen the colour and shape of the crab.

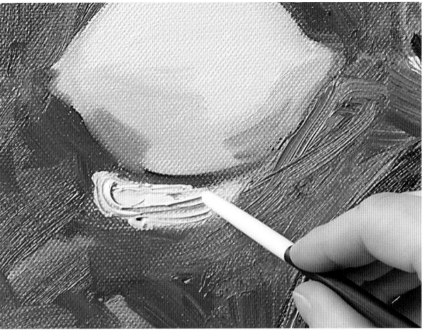

14 Use the wrong end of the brush to scratch into the paint to modify the white spots and lines of the tablecloth, so that some of the underlying blue and yellow shows through. Add further refinements to the crabs and prawns with the orange, red, and light pink mixes.

▼ Still life

The treatment of the background and shapes surrounding the plate of crustaceans has been kept as simple as possible. This allows attention to be focussed on the intricate shapes of the crab and prawns.

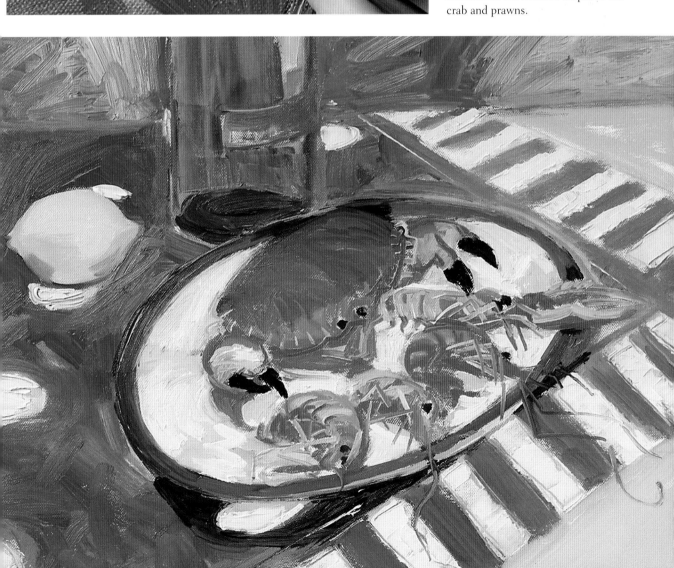

11 Bicycle in the sunlight

This painting of a bicycle leaning against a wall contains two colour contrasts. Yellow and lilac contrast in the colours of the wall and its shadows, and a more subtle contrast of red and green can be seen in the frame of the bicycle. The shadows of the bicycle are also tinged with greens to make the red of the bicycle appear more vibrant. The wall is painted first, as seen through the bicycle frame, and the bicycle then emerges. The front wheel is larger than the rear wheel, because it is closer to the eye. The shapes of both wheels contrast with the strong verticals in the painting.

EQUIPMENT
- Canvas
- Brushes: No. 2 round, No. 8 flat, No. 6 and No. 8 filbert
- Painting knives: No. 24
- Cotton rag
- Turpentine or odourless thinner, painting medium
- Cadmium yellow, cadmium red, titanium white, viridian green, ultramarine blue, alizarin crimson, cerulean blue, lemon yellow, raw sienna, rose madder, cobalt blue, Prussian blue, ivory black, burnt sienna, cobalt turquoise

TECHNIQUES
- Scumbling
- Adding highlights

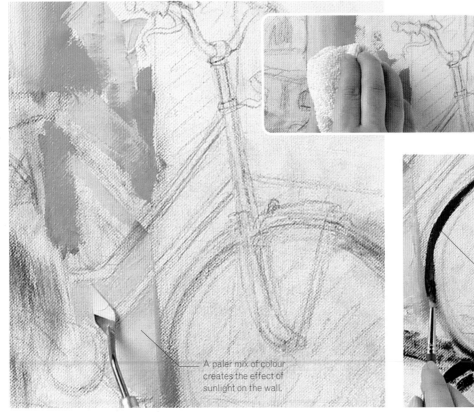

A paler mix of colour creates the effect of sunlight on the wall.

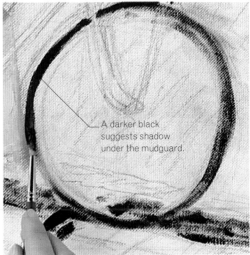

A darker black suggests shadow under the mudguard.

1 Mix cadmium yellow and cadmium red with painting medium to paint the shadows on the yellow wall, including the area seen through the wheel. Add titanium white to the mix to paint the areas of the wall in sunlight, using the No. 24 painting knife. Dip a cloth in turpentine and rub it vertically over the paint for a straight line.

2 Mix cadmium red, viridian green, ultramarine blue, and turpentine to make a thin black mix. Paint the wheels with this mix using the No. 2 round brush. Anchor the tyres on the ground by painting their shadows.

BUILDING THE IMAGE

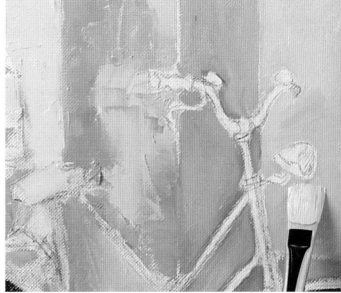

3 Paint the shadows on the whitewash wall with a lilac mix made from alizarin crimson, cerulean blue, and titanium white, using the No. 8 filbert brush. Painting the spaces inside the frame throws the bicycle into relief.

4 Mix cadmium red and cadmium yellow for the areas in sunlight to the side and for the basket. Mix cerulean blue and titanium white with the lilac mix for lighter areas of the white wall, adding lemon yellow in places.

"White is 95 per cent not white – it reflects the colours around it."

5 Add alizarin crimson and raw sienna to the lilac mix to make a warmer colour for the shadow areas on the road and the kerb. Paint with directional strokes using the No. 8 filbert brush. Add more raw sienna to the mix and scumble this colour over the road and on the wall on the far right and far left.

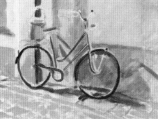
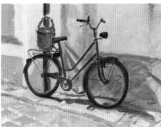
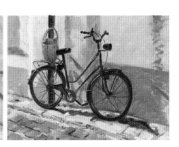

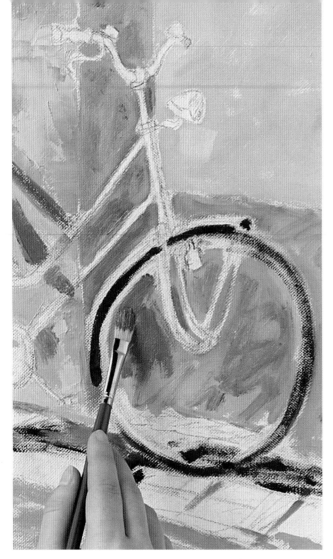

6 Mix rose madder and cobalt blue. Using the No. 8 filbert brush on its side, scumble the colour over the shadow areas on the wall. Use the thin black mix and the No. 6 filbert brush to add further precision to the wheels and to paint the shadow of the wall on the ground.

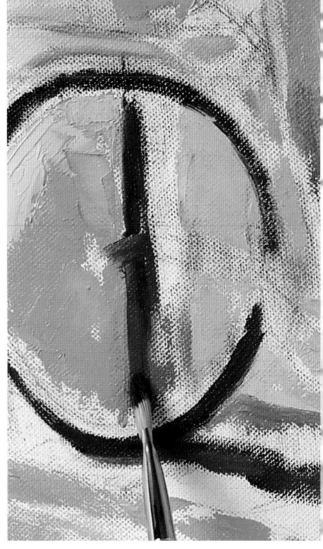

7 Mix a brownish green from cadmium red, cadmium yellow, Prussian blue, and ultramarine blue. Use this mix to paint the drainpipe. Add the same colour to the shadows on the wheels and further develop the shadows of the bicycle and drainpipe on the ground, emphasizing and softening the shadow area.

8 Paint the bicycle with a thin mix of pure cadmium red and turpentine, using the No. 2 round brush. Where the paint touches the black mix the red will become a darker shade, which can be left or overpainted with more cadmium red. Add ivory black to the drainpipe.

9 Mix burnt sienna with cadmium red for the darkest red areas of the bicycle frame. Use this mix on the wicker basket and to define the tyres. Use the strong black mix from step 2 for details of the handlebars, pedals, front and rear lights, saddle, and lock.

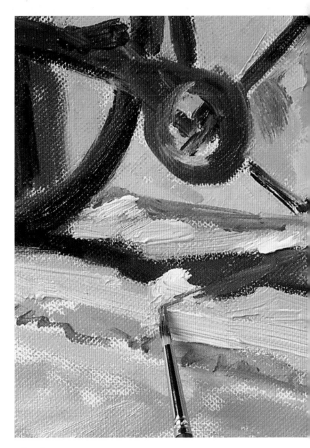

10 Mix viridian green, cadmium red, and cobalt turquoise. Use this mix to paint the darker areas of the basket, and to lighten the saddle and parts of the wheels. Put this green mix next to areas of red on the bicycle to make them appear more vibrant.

11 Make a different green mix from cadmium yellow, titanium white, and cerulean blue to add the divisions of the pavement and kerb. Put touches in the shadow of the bicycle.

12 Mix a soft green from lemon yellow, cadmium yellow, and cobalt blue for shadows on the bicycle. Add cobalt blue and alizarin crimson to the mix to paint the shadows cast by the bicycle on the wall. Warm the shadows with a mix of cadmium yellow and cadmium red.

TRUST YOUR EYES

In general, paint what you can see or count. Don't paint details you know an object has if you can't actually see them.

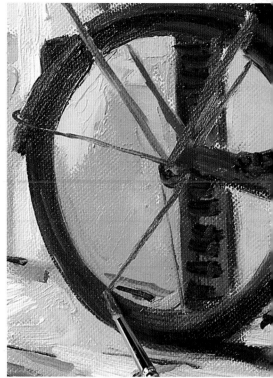

13 Add titanium white to the soft green mix and paint this lightly in the foreground. Add ivory black to the mix and draw in irregular lines to indicate the kerbstones and cobblestones.

14 Suggest some spokes with the dark red bicycle mix, varying the colour as you go. Paint details on the bicycle with ultramarine blue and define the saddle with this mix.

15 Add some of the black mix to the shadow by the front wheel to redefine it. Make a fairly liquid mix of titanium white with turpentine. Use this to add highlights to the metal of the bicycle frame and wheels.

▼ Bicycle in the sunlight

All the horizontal lines in the painting have been placed on the diagonal, making the picture more dynamic. The angled shadows of the bicycle cast on the wall and the pavement reinforce the effect.

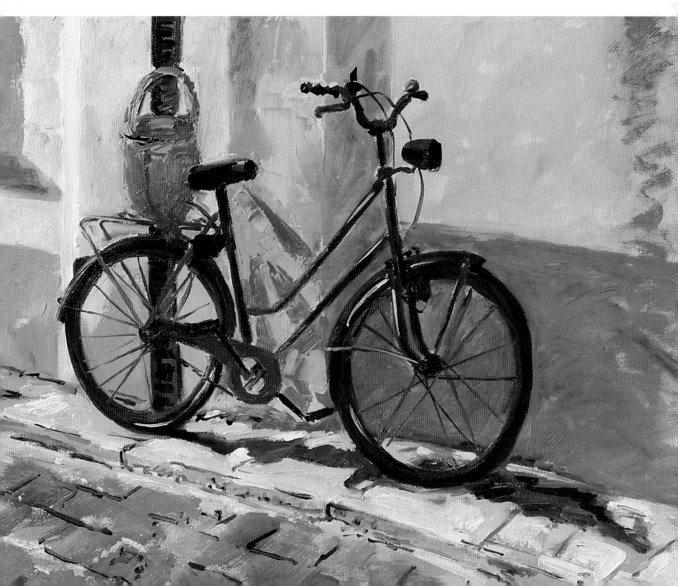

12 Portrait of a girl

This portrait is started with a thin glaze. The features are found by lifting out some of the glaze with a cloth. Capture areas of light on the face rather than focusing on the details, seeing lights and darks as abstract shapes. Gradually soften the abstract shapes as you work to emphasize the structure of the face. The final shape of the straight neckline, the cheekbone, and the pigtail are established by working up to them from the background, using a painting knife flat. In line with the bold shapes, a scrunching technique is used to create texture in the cardigan.

EQUIPMENT

- Canvas
- Brushes: No. 2 round, No. 8 and No. 12 flat, No. 4, No. 6, and No. 8 filbert
- Painting knives: No. 21
- Cotton rag, aluminium foil
- White spirit, turpentine or odourless thinner, impasto medium
- Cadmium red, cadmium yellow, burnt sienna, viridian green, sap green, titanium white, cerulean blue, Prussian blue, ivory black, yellow ochre, transparent yellow, ultramarine blue, brilliant pink, cobalt blue, cobalt turquoise, lemon yellow, permanent rose

TECHNIQUES

- Lifting out
- Scrunching
- Softening

1 Draw the face, checking the proportions carefully. Mix cadmium red, cadmium yellow, and burnt sienna for a base skin colour. Apply with light brushstrokes, and use a rag to blend and lift out.

2 Create a dark base colour for the hair by mixing viridian green, sap green, and titanium white. Use the No. 4 filbert brush to paint this mix in the darkest areas of the hair, around the cheeks, and on the eyes.

BUILDING THE IMAGE

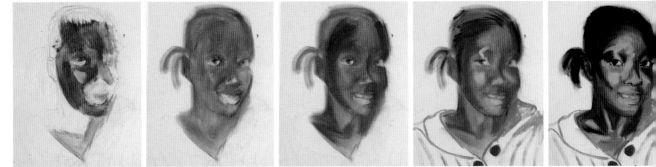

3 Dampen the cloth with some white spirit and use it to lift out some of the paint in those areas where the skin reflects the light.

4 Paint in the outline and colour of the cardigan with a mix of cerulean blue and titanium white, using the No. 6 filbert brush.

5 Mix Prussian blue and ivory black, and block in the hair with the No. 12 flat brush. Switch to the No. 2 round brush to define the eye lines.

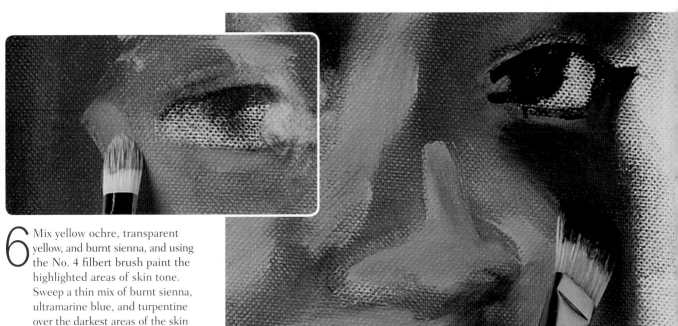

6 Mix yellow ochre, transparent yellow, and burnt sienna, and using the No. 4 filbert brush paint the highlighted areas of skin tone. Sweep a thin mix of burnt sienna, ultramarine blue, and turpentine over the darkest areas of the skin with the No. 8 flat brush.

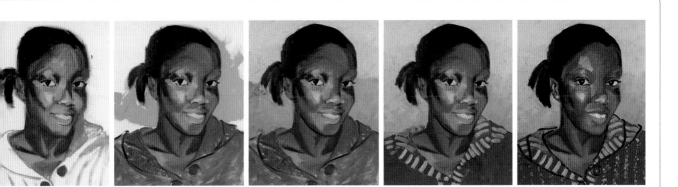

7 Define the mouth with the darker skin mix using the corner of the No. 8 flat brush. Mix brilliant pink with some titanium white to create a pale pink. Paint in the pink tones of the lips, nose, and cheeks using the No. 4 filbert brush.

8 Return to the yellow highlight skin tone mix and add some titanium white. Paint in the delicate detail of the whites of the eyes, and add the base colour for the teeth, using the No. 2 round brush. Mix cobalt blue and cerulean blue, and scumble in the base colour of the cardigan.

9 Use the dark skin mix from step 6 to define the jawline. Mix cerulean blue, ultramarine blue, cobalt turquoise, and titanium white with some impasto medium. Apply to the background with the No. 21 painting knife, using the edge of the knife to create a definite line around the head.

SKIN MID TONES

Spend time getting the mid tones in the skin right, as well as the highlights and shadows. The mid tones play an important role as they soften the face and pull the portrait together.

10 Spread a mix of Prussian blue, ultramarine blue, and titanium white on the cardigan with the No. 21 painting knife. Add titanium white and a little cobalt turquoise to the mix for the light blue stripes and paint them with the No. 8 flat brush.

11 Scrunch up some aluminium foil. Dab it against the cardigan to disturb the paint surface and create the textured effect of the wool. Dip the foil in some lemon yellow and then dab it along the cardigan in vertical lines to create the yellow pattern.

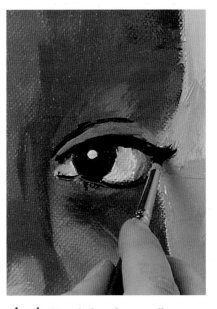

12 Return to the darker skin mix to reinforce the shadows on the neck and lower part of the face with the No. 8 filbert brush. Add some cadmium red to the mix to reinforce the mid tones.

13 Paint the upper lip a darker tone than the bottom lip, which catches the light. Mix permanent rose and brilliant pink, and apply this carefully using the No. 4 filbert brush.

14 Mix a little cadmium yellow into titanium white and turpentine to dot into the eyes. Add titanium white to the background mix for the eyelids. Define the eye line and eyelid crease with ivory black.

15 Mix brilliant pink, titanium white, and lemon yellow, and use this to highlight the cheek and brow with the No. 2 round brush. Check the mid tones of the skin and lighten in places with a mix of burnt sienna and titanium white using the No. 8 filbert brush.

16 Finish the picture by softening the hairline, lifting and merging some of the colour with your fingers. Give some character to the front teeth by adding a little pure titanium white. Do not delineate every tooth; just give an impression of the overall shape.

"Paint lights and shadows as distinct shapes."

Portrait of a girl ▶

In this portrait, the skin tones used have been carefully placed and not overworked, capturing the face's form. Blending the skin colour of the forehead into the hairline softens the overall effect.

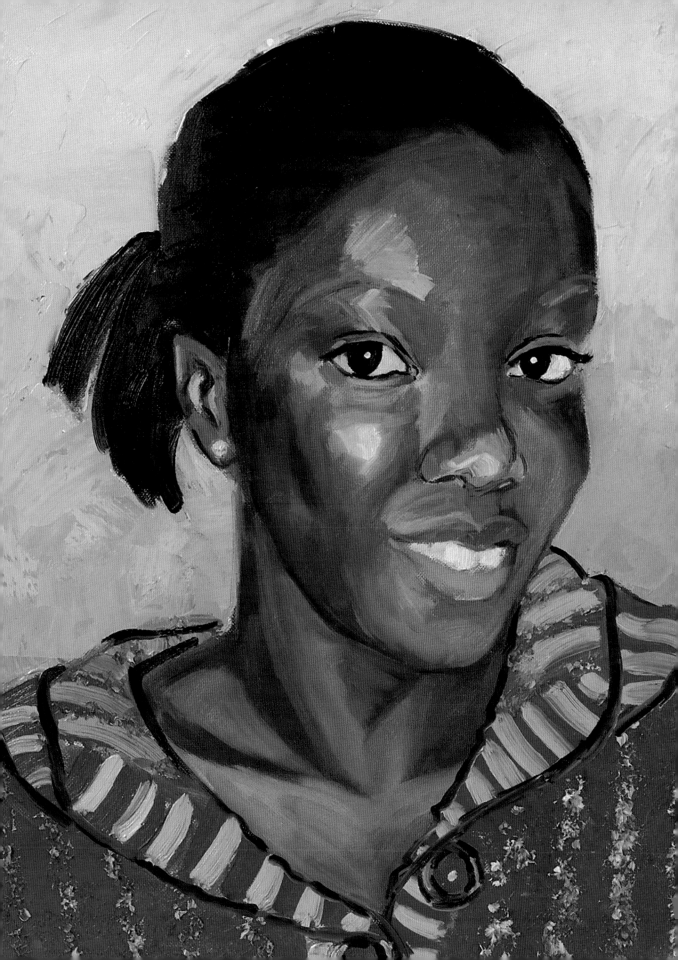

Glossary

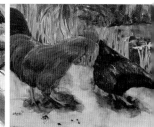

Acrylic gesso
A white acrylic undercoat used to prevent oil paints sinking into the support.

Alkyd paint and medium
Paints and mediums containing an oil-modified resin, which accelerates drying time.

Artists' colours
The highest quality oil paints, which possess more pigment, brilliance, translucency or opacity, stability, and choice of colours than the less expensive students' colours.

Atmospheric perspective
A way of creating depth in a painting by making colours paler and bluer the further back they are in a scene.

Blending
A way of letting two colours merge gradually with each other on the picture plane by brushing or feathering them lightly.

Broken colour
A method of giving colour to an object with little touches of various, partially overlapping colours from a small colour range, to give more interest. The colours are not blended together but left broken, only appearing to merge when viewed from a distance.

Colour field
Any area of colour that does not constitute a line.

Colour wheel
A design widely used to demonstrate the theory of colour in an easy way. It explains the relationship between primary, secondary, complementary, and warm and cool colours.

Combing
A technique by which a pattern of fine parallel lines of raised and indented paint is drawn into thick paint with a comb.

Complementary colours
Colours from opposite sides of the colour wheel, one a primary colour, the other a secondary colour which is mixed from the two other primary colours.

Cool colours
Colours which have a bluish tone. Cool colours appear to recede in a painting.

Dabbing
A way of applying paint in touches without stroking the surface of the support with the brush.

Dipper
A set of two small round metal containers for painting mediums that can be clipped onto the palette.

Dry brushwork
An application of paint in which little medium is used to moisten it. The brush skims lightly over the surface, creating uneven broken marks.

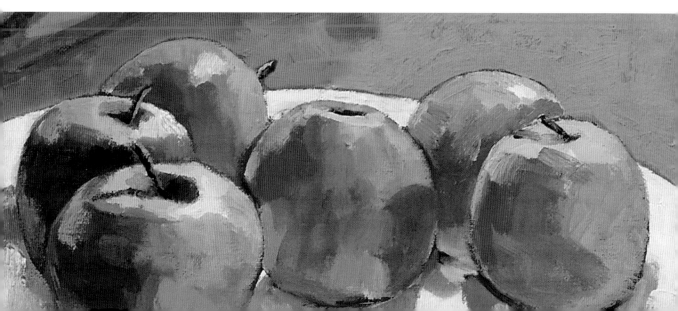

Feathering
A method of working one colour very lightly over another with a large or fan-shaped brush. The result is a soft shimmering colour made up of the two colours combined.

Focal points
Points of interest which the eye is drawn to immediately, whether because of the perspective, the colour, or an intricate shape. A painting should have one or more focal points. Multiple focal points will lead the eye around the picture plane.

Format
Format describes the shape of a painting. A horizontal painting is a landscape format; a vertical painting is a portrait format.

Glazing
The application of one transparent colour over another, so that the first colour shows through the second one, and creates a shimmering, translucent effect.

Hatching
A technique of applying paint in short parallel strokes over another paint layer to create a new colour, which is not blended on the canvas but is created by the colours appearing to merge when seen from a distance. In cross hatching, a second layer of parallel strokes is applied in a slightly different direction.

Impasto
Thick, opaque paint laid with a brush or painting knife. The paint is applied with short dabs or with a definite stroke, so that it does not blend with earlier applied paint.

Intermediate colours
The colours between the primary and secondary colours on the colour wheel, made by mixing a greater proportion of one primary colour into the secondary colour.

Lifting out
Removing some of the applied paint from the painting with a dryish brush or a cloth.

Linear perspective
The art of showing depth in a painting by making parallel lines converge on the eye's horizon. Figures and objects become smaller the further they are set back in the scene.

Luminosity
A transparent colour has luminosity when it appears to have an inner light, caused by the white of the undercoat, or other colours applied previously, showing through.

Medium
A substance that is used to modify the fluidity or thickness of oil paints. The paint is mixed with the medium on the palette until it has the desired quality and is then applied to the support. Thinning, glazing, thickening, and impasto mediums are available.

Mid tones
Mid tones are all the variations of tone between the darkest and the lightest tone in a painting.

Neutral colours
Neutral colours are mixtures of three colours or colours toned down with black. They do not reflect as much light as bright colours, which they make look brighter when placed beside.

Oil
A medium, usually consisting of linseed oil, which thickens the paint and makes it easier to apply to the surface. Oil is mixed with turpentine in order to produce thinner mixtures.

Palette
A wooden plank or block of plasticized paper on which to mix paints. The word is also used to describe colours used by a particular painter or on a particular occasion. Every painter has his or her own favourite palette of colours. Some scenes require a different palette of colours; for example, a summer landscape will need a different palette to an autumn one.

Plasticity
A tactile quality which makes you want to touch the work to feel how it is made. Oil paint has this quality because it can be used to create visible brush marks and thick textures.

Primary colours
There are three primary colours, yellow, red, and blue, which cannot be made by mixing any other colours.

When placed next to each other they give the strongest contrast of all colours. On the colour wheel they are placed opposite each other, forming a triangle on the wheel.

Rubbing out
An action which takes paint off the support, usually by wiping an area with a cloth, which may be soaked in turpentine. A residue of paint will be left, which will add to the effect of the subsequent overpainting.

Scratching in
Any action whereby marks are scratched into applied paint to give added texture. Any moderately sharp object is suitable; for example, nails, the side or point of a painting knife, the back of a brush handle, or a comb, as long as the support is not damaged.

Scrunching
A technique that uses the texture of scrunched-up paper, plastic, or aluminium foil to stamp texture or a colour into a paint layer.

Scumbling
A technique in which a brush is used to apply paint which has not been much moistened with medium. The brush strikes lightly over the paint surface, depositing paint irregularly on the raised and dryer parts of the surface and so creating an uneven texture. (*See also Dry brushwork.*)

Secondary colours
Secondary colours are the three colours created by

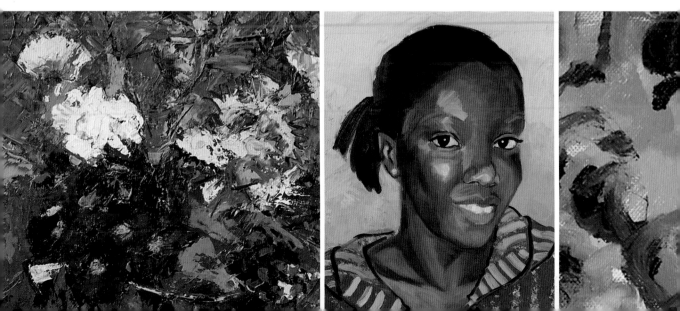

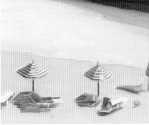

mixing two primary colours. Yellow mixed with red makes orange, red and blue make violet, and blue and yellow make green.

Softening
A hard edge can be softened with a brush and paint, a cloth, or even the hand.

Stippling
The application of relatively neat dots to form a colour field. Dots in two or more different colours can be applied next to or partially overlapping each other for a more interesting paint surface, forming a new colour when viewed from a distance.

Students' colours
An inexpensive range of oil paints, which may not have

as much pigment, brilliance, transparency or opacity, and stability as artists' colours.

Support
Any surface upon which the paint is laid, from paper and boards to cotton or linen canvas, stretched on a wooden frame.

Thick over thin
The invariable rule of oil painting that thick paint, which has more oil in it, should be painted over thinned paint, and not the other way around in order to avoid cracking of the surface layer of paint (also referred to as "fat over lean").

Tone
The relative lightness or darkness of a colour.

Some colours are inherently light or dark in tone: yellow, for example, is always light.

Turpentine
A flammable solvent with a strong smell used as a painting medium to thin paints. It is also used to clean brushes and hands. Odourless thinner is an effective substitute.

Varnishing
The application of a protective resin over a painting that has thoroughly dried, which takes from a few weeks to up to six months. Varnish is removable.

Viewfinder
A device which helps the artist to decide upon a satisfactory composition. Two L-shaped pieces of cardboard are held up to form a frame through

which to view the scene; they can be adjusted as necessary.

Warm colours
Colours which have a reddish tone. Warm colours seem to come forward in a painting and can help establish perspective.

Wet-in-wet
Since oil paint takes a long time to dry, the entire painting is done wet-in-wet. Thicker paint is applied with each subsequent layer and can be worked in totally or partially with the previous layer on the support.

White spirit
A flammable solvent that is used to clean brushes and hands after a painting session. It evaporates quickly.

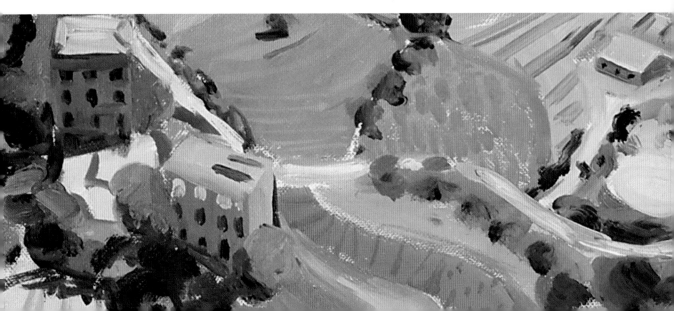

Index

Acknowledgements

Dorling Kindersley would like to thank:
Simon Murrell for design help; Diana Vowles for
editorial help; Sarah Hopper for picture research;
Simon Daley for jacket series style; Ian Garlick
for jacket photography.

Design Gallery would like to thank:
Juliette Norsworthy and Kate Clarke for design;
Lynn Bresler for proofreading; Ursula Caffrey
for indexing.

PICTURE CREDITS

Key: t=top, b=bottom, l=left, r=right, c=centre
p.40: Musée Marmottan, Paris/www.bridgeman.co.uk
(tl); *p.58*: © Christie's Images Ltd (br); *p.59*: Private
Collection, © Lefevre Fine Art Ltd/www.bridgeman.
co.uk (br); *p.79*: © Judith Miller/DK/Freeman's; *p.80*:
Hermitage, St.Petersburg, Russia/www.bridgeman.
co.uk (tl); *p.81*: © Christie's Images Ltd. (t); *p.101*:
Lindsay Haine; *p.102*: Private Collection, ©
Christie's Images/www.bridgeman.co.uk (br); *p.103*:
Palazzo Pitti, Florence/www.bridgeman.co.uk (bl).

All jacket images © Dorling Kindersley.